America and the Sea

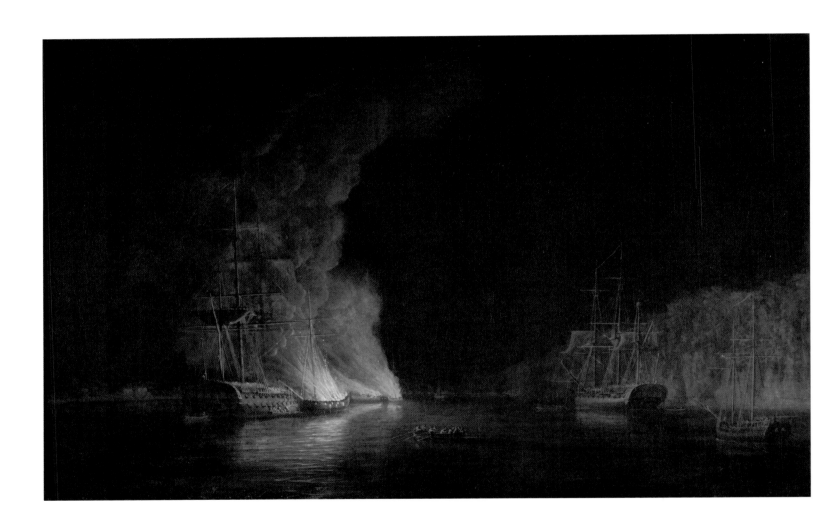

America and the Sea

TREASURES FROM THE COLLECTIONS OF
MYSTIC SEAPORT

INTRODUCTION BY

Stephen S. Lash

ESSAYS BY

Daniel Finamore, Nicholas Whitman, Erik A. R. Ronnberg Jr., William Fowler,

Michael McManus, Llewellyn Howland III, and Ryan M. Cooper

MYSTIC SEAPORT

IN ASSOCIATION WITH

YALE UNIVERSITY PRESS

NEW HAVEN AND LONDON

Mystic Seaport gratefully acknowledges the Henry Luce Foundation,
whose generous financial support helped make this publication possible.

Mystic Seaport
75 Greenmanville Avenue
P.O. Box 6000
Mystic, CT 06355-0990

First edition

Created and produced by Constance Sullivan/Hummingbird Books
Manufactured in China

ISBN 0-300-11402-8
Library of Congress Control Number: 2005930981
Published by Yale University Press in association with Mystic Seaport

Mystic Seaport—the Museum of America and the Sea—is the nation's leading maritime museum,
presenting the American experience from a maritime perspective.
Located along the banks of the historic Mystic River in Mystic, Connecticut,
the Museum houses extensive collections representing the material culture of maritime America,
and offers educational programs from preschool to postgraduate.

For more information, call us at 888-seaport, or visit us on the Web at www.mysticseaport.org

(title page) Dominic Serres, *"Phoenix," "Rose," "Asia" and "Experiment," British Squadron on the Hudson River, attacked by fire ships and galleys, 16 August, 1776*, 1777, oil on canvas, 25 x 40 in. (1949.804)

French-British marine artist Dominic Serres (1722–1793) was a mariner before arriving in England as a prisoner of war in 1758. He studied art, was a founder of the Royal Academy, and was appointed marine painter to King George III in 1790.

Serres based this dramatic scene on a sketch by Sir James Wallace, commander of HMS *Experiment*. It depicts an unsuccessful attempt by George Washington's Continental forces to destroy or drive off a British squadron that controlled the lower Hudson River and threatened to cut off supplies to the Continental Army.

CONTENTS

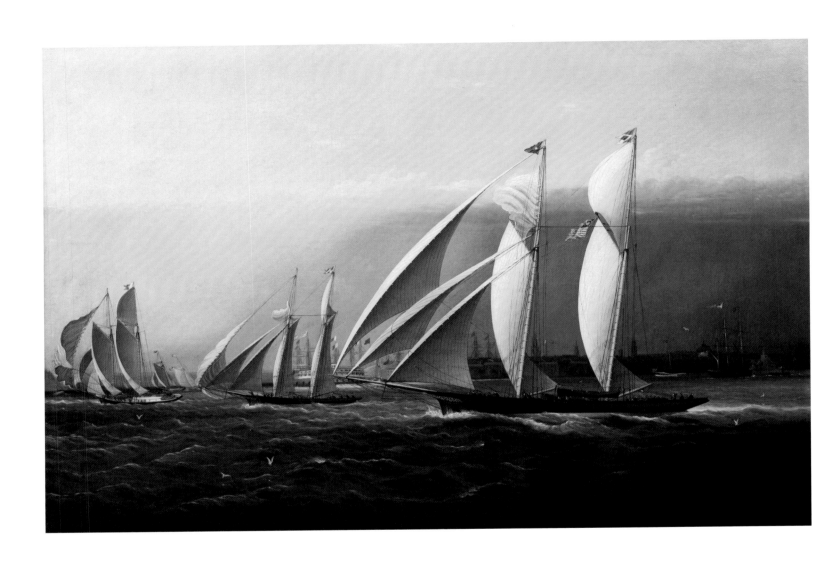

James E. Buttersworth, *Race off the Battery, New York Harbor*, ca. 1870, oil on canvas,
20⅛ x 30 in. (1976.172)

The nearest schooner is the *Dauntless*, ex-*L'Hirondelle*, built at Mystic, Connecticut, in 1866. Close inspection of the painting reveals that Buttersworth changed the set of the *Dauntless*'s sails before completing the painting.

James E. Buttersworth (1817–1894), the son of a British naval officer and marine artist, was an accomplished painter when he emigrated to the U.S. about 1846. A wonderfully prolific master at depicting dramatic sky and water in the style of the Hudson River School, Buttersworth is best known for his vessel portraits and yachting scenes.

INTRODUCTION

I am pleased to introduce this celebration of the remarkable collections at Mystic Seaport. While I cannot pinpoint the day—the exact hour—that I came under the spell of all things maritime, I confess my enthusiasm has been lifelong, taking me on an extraordinary journey and teaching me that so much of American history is in fact maritime history.

Growing up in Boston I experienced firsthand the many ways in which the sea is intricately interwoven with America's cultural, political, and economic history. Coastal New England is steeped in maritime heritage, from its fishing industry to the rich history of Boston Harbor as a busy trading port, the center of the famous Boston Tea Party, a port of civil defense in the War of 1812, and the first western terminus for Samuel Cunard's celebrated passenger ships. I was fortunate to grow up alongside the sea, enjoying the summer pleasures of Cape Cod, developing a full-blown obsession with ocean liners as a teenager, which in turn led to a passion for collecting objects associated with transatlantic travel.

But I am not alone in my love of the sea. One need only read Ernest Hemingway's *Old Man and the Sea*, Samuel Taylor Coleridge's "Rime of the Ancient Mariner," or Eugene O'Neill's *Beyond the Horizon*, listen to Bobby Darin sing "Beyond the Sea," see *An Affair to Remember* or *Titanic*, or look at Winslow Homer's *Eight Bells* to understand the impact of maritime themes on artists of all mediums. Indeed, at age 65 I am hard-pressed to find any artistic medium, whether music, literature, film, or fine art, that does not illuminate to haunting and memorable effect the extent of the interaction between people and the sea.

Yet it is the appearance of nautical images in art that has particularly captivated my attention. Imagine my delight, then, to have the pleasure of visiting Mystic Seaport, so close to my own home in Stonington, Connecticut, to experience the Museum's outstanding marine paintings, its collection of maritime photographs (the world's largest), beautiful prints, watercolors, and works on paper. Yarn paintings, reverse paintings on glass, sailor's valentines, scrimshaw, ship figureheads, silver yachting trophies, shadowbox ship models, and ships in bottles are among the many treasures unfamiliar to the general American public, unless one has had the good fortune to visit this superb museum as frequently as I have. Hidden within the collections are wonderful examples of true American folk art, objects possessed of a sense of worthy purpose that transcends their simple origins. All of these expressions combine practical and aesthetic considerations—interwoven with the context of time, place, form, and function. These creative ways of expression can only be called art.

Mystic Seaport—the Museum of America and the Sea—a nationally recognized living-history destination, is one of the finest and most comprehensive maritime museums in the world. This lavish volume highlights for the very first time more than 200 of the Museum's finest objects, presenting them as significant

representations of American art and pairing them with essays by distinguished experts on the artists and craftsmen depicted and their individual forms of expression.

Elegantly designed and presented, *America and the Sea* provides an opportunity for readers everywhere to discover the indisputably relevant role of maritime material culture in American life and art, and focuses well-deserved attention on artwork that has not yet been widely seen, making known to a larger and more diverse audience the true treasures that reside in this museum.

America and the Sea is, most importantly, a generous invitation from Mystic Seaport to take a serious and in-depth look at the maritime collection of an important museum—one that displays maritime art as the serious art form that it is—and to fall in love, as I did long ago, with America's fascinating, ever-changing, influential, and important role in the universal world of things maritime. The beautifully photographed pages of this stunning book deserve a place in the art history section of libraries everywhere, giving testament to the superb quality of the works produced by this fine selection of artists and craftsmen.

The publication of *America and the Sea* would not have been possible without generous support from the Henry Luce Foundation.

STEPHEN S. LASH

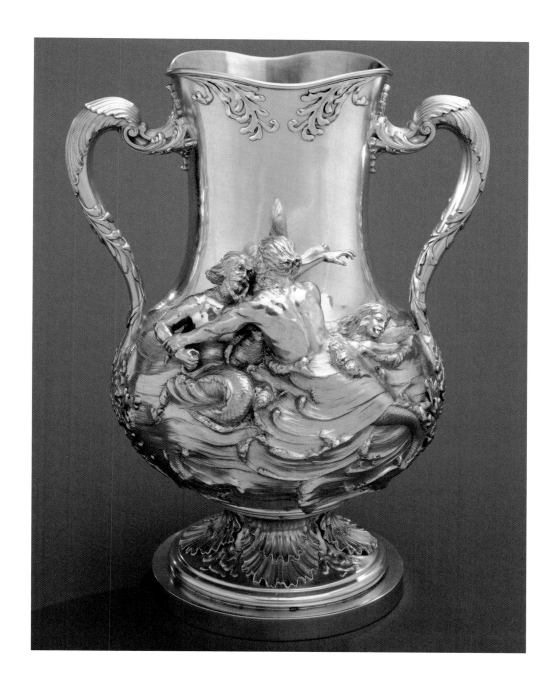

Black, Starr & Frost, New York Yacht Club Defender Trophy, 1895, stirling silver, height 18½ in.
(1961.894)

The New York Yacht Club commissioned one of New York's most prominent silversmiths, Black, Starr & Frost, to produce this elaborate trophy to thank William K. Vanderbilt for successfully defending the America's Cup against the British *Valkyrie III* with his 123-foot Herreshoff-designed sloop *Defender* in 1895.

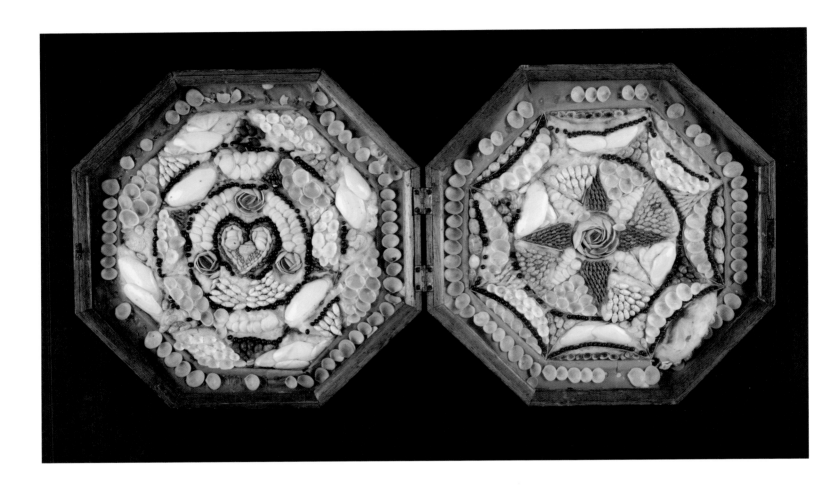

Unidentified artist, "Sailor's Valentine," ca. 1900, 13½ x 3 in. (1952.2107)

Though popularly known as a "sailor's valentine," with the implication that a homesick sailor made it while on board ship as a gift for a loved one at home, the reality of this charming form of folk art is a bit different. These boxed assemblages of shells, in colorful geometric patterns, were actually made by islanders to sell to visiting sailors and travelers, particularly at Barbados.

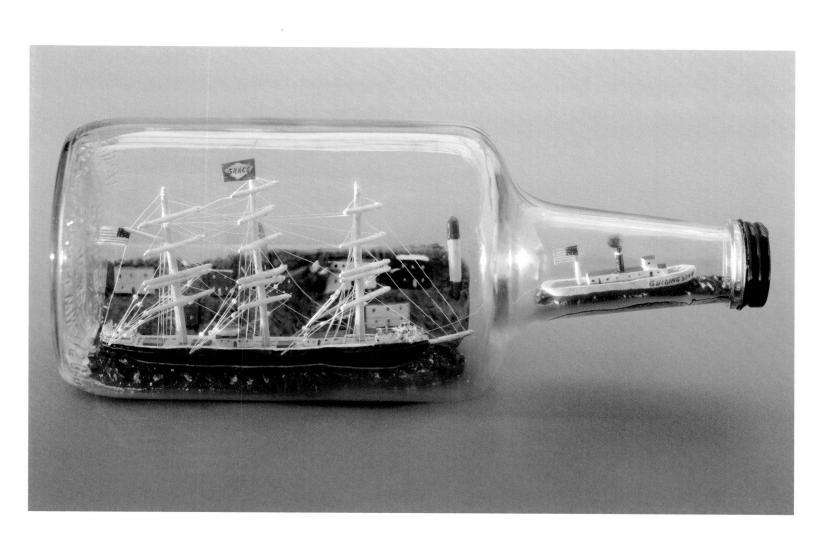

Hugo Nelson, model in wine bottle of ship *W. R. Grace*, n.d., length of model, 11½ in. (1974.473)

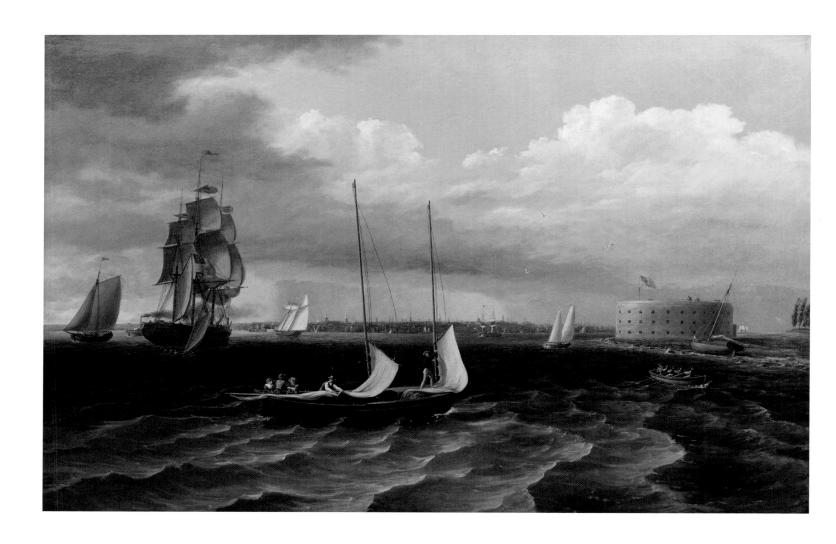

Thomas Birch, *Castle William in New York Harbor*, ca. 1830, oil on canvas, 30¾ x 47½ in. (1965.55)

Thomas Birch (1779–1851) emigrated to Philadelphia from England as a young man and evolved from portrait painter to marine artist, specializing in historical paintings and accurate seascapes like this one.

 With its broad bay, convenient water connections to the developing portions of the United States, and strong economic connections with European ports, New York led all American seaports in foreign trade. In this painting, a large packet ship passes Castle William on Governors Island on her way to a berth at one of the East River piers in the background. Harbor traffic includes a coastal topsail schooner heading up the harbor, an oceangoing brig lying at anchor, a steamboat and a Hudson River sloop headed down the bay, and, at center, a pettianger with a party of men and women on board, perhaps seeking recreation in what was normally a harbor workboat.

MARITIME PAINTINGS

Maritime painting employs diverse forms of expression to convey the profound artistic and cultural impact of the sea and seafaring on people's lives. Struggling against the elements, sailing confidently, or resting at anchor, images of ships on the sea evince a range of ideas and emotions. Created by sailors to document unique personal experiences and by professional artists striving for universal symbolic representation, marine painting richly embodies the continuously evolving relationship of humanity to the marine environment.

The sea has always figured prominently in American life. For generations, a large segment of the population engaged in fishing, whaling, coastal or deepwater trade, along with ancillary shoreside industries, while others experienced an arduous transatlantic sea voyage firsthand as immigrants. The earliest paintings, watercolors, drawings, and prints of American subjects articulate the expansionist philosophy that brought many colonists to North America. At the dawn of American commercial sail, most portraits of American ships were actually painted overseas and transported back home on the very ships they depicted. Artists from the Mediterranean and Baltic ports to Canton (Guangzhou, China) painted images with an overarching documentary character, primarily in watercolor and often including a distinctive lighthouse, breakwater, or mountain to indicate the voyage destination. Even though most of the artists who created this first generation of marine art never saw these shores, it had a strong impact on regional artists who followed.

Most of those who emigrated to America were seeking new opportunities. Among the trades and skills they brought, marine painting could well have been the most specialized. From the Anglo-Dutch wars of the mid-1600s, naval victories were celebrated in oils by Royal appointments and unofficial followers who employed a narrow range of artistic conventions to record sea battles. From that relatively uniform European aesthetic, painters who emigrated to America gradually adjusted to their new physical and creative milieus. They arrived carrying the academic traditions of various European schools of painting, but by embracing the new natural setting as a foil for subjects of interest to their new audiences, they discovered novel approaches to artistic expression that became uniquely American. Upon arrival, artists such as Thomas Birch drew upon techniques and compositions reminiscent of French and Dutch marine painters while James Buttersworth built upon English traditions to create work for their new American audiences. Their work resonated among residents for whom images of maritime life were laden with significance, and they influenced a new generation of native-born painters.

In addition to professionals, many sailors and other self-taught artists adopted the techniques and visual vocabulary of their specialized occupational circumstances to create paintings that evoke their distinctive experiences. Many sailors received naval or navigational training, which involved rendering into their logbooks ink pictures of ships at various points of sail. From this initial training in observational record-keeping, many created more imaginative works that preserved stories or recounted events of personal importance.

Two distinctive examples are scenes of Heard Island and of Desolation Island (pages 20–21). Neither work is signed, but there is little doubt that each was created by an artist with firsthand knowledge of these remote and forbidding landscapes. The subjects depicted, seal and whale hunting, also speak to specialized interest in these places beyond their dramatic locales. In the home ports of the men and ships in these scenes, the paintings represented prosperity.

The nineteenth century was the heyday of the painted ship portrait, perhaps the most specialized genre of marine art. The best ship portrait painters melded artistic skill with extreme nautical accuracy and detail, delineating shape and proportion of rig, hull, deck arrangement, and bow carving. The traditional venue for commercial ship portraiture was a business environment such as the shipping office, where it allowed a shipowner to show off the attributes of his vessel to a prospective customer, even when the vessel was not in port. Paintings like James Bard's portrayal of the side-wheel steamer *Connecticut* communicated simultaneously on many levels—shipowners saw in them bold commercial advertisements, shipbuilders and technically oriented people saw in them accurate and informative construction drawings, and to the general public they were vibrant works of art that evoked America's progress on the seas.

Today, we look at these paintings as if into a window in time. They speak to us about the romance of seafaring life in the age of sail, the heights of nineteenth-century technology, and commercial enterprise during a simpler and seemingly less regulated era. But to the nineteenth-century viewer they represented quite the opposite; they portrayed recently developed, highly sophisticated technology utilized in the pursuit of profitable but often dangerous and unpredictable business. Ship portraits often display encoded information that may be difficult for a modern audience to recognize and interpret because it requires knowledge that was common in maritime communities of the time but is arcane today. Not only did the presentation of seas and skies communicate sailing conditions, such as currents and wind directions, but the best artists presented the proper sail configuration for the environment they had created. Further, superlative works such as William G. Yorke's painting of the ship *Galatea* (page 23) employ elements like an identifiable background and approaching pilot boat to create a complete narrative, while conveying information about the ship and her owner in the signal flags atop the masts.

A broadening audience for maritime art marked a departure from the documentary tradition and a sacrificing of strict nautical veracity in favor of experiments in artistic expression. Though the technical proficiency to portray the hull, spars, and rigging in accurate proportion was still essential, it became merely a starting point toward a more majestic goal of a selective realism that focused the image on a finely honed theme. For some, such as the painter William Bradford, it was the placement of people and ships within a dramatic natural setting that was sometimes stark and sometimes beautiful, but always imbued with broad significance for humanity. For other artists, the theme was more often one of celebration. Among the most overtly celebratory expressions in American maritime art are the paintings of James E. Buttersworth. Almost immediately upon his arrival in America in the mid-1840s, Buttersworth began creating large-format broadside views of famous American ships. Many of these were converted into lithographic prints that circulated widely, becoming populist icons of Americana.

The burgeoning popularity of yacht racing in the 1850s inspired Buttersworth to paint pictures of greater compositional sophistication. He often painted narrative portrayals of yachts in tense and momentous juxtaposition, often sailing on opposite tacks or at different angles while rounding a mark. Rather than retell a story that his audience already knew, he elicited in his viewers some of the excitement that had existed during the actual event when the outcome was far from certain. Buttersworth was among the first marine artists to enter the canon of American fine art, when, during the 1939 New York World's Fair, a vibrant yacht racing scene was displayed at the Metropolitan Museum of Art.

Maritime painting is not a singular codified genre or subject to be understood at a glance. Offering varying interpretations of commercial adroitness, technical proficiency, and the transience of human existence against the backdrop of the timeless deep, maritime painting in the Mystic Seaport collection reflects America's enduring fascination with the mystique of the unknowable sea.

DANIEL FINAMORE

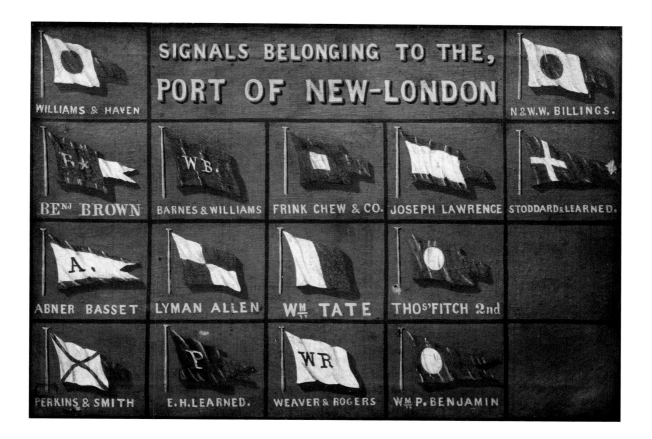

John Ewen Jr., *Signals Belonging to the Port of New-London*, 1844, oil on canvas, 17 x 24 in. (1939.1563)

John Ewen Jr. is an obscure artist who painted portraits of a number of New London, Connecticut, whaleships in the 1840s.

These are the flags of the owners of the whaling vessels of New London at the height of the industry in the mid-1840s. An owner's flag, or house flag, was flown at a ship's masthead for identification, especially when entering port or when ships passed each other at sea and communicated with flags.

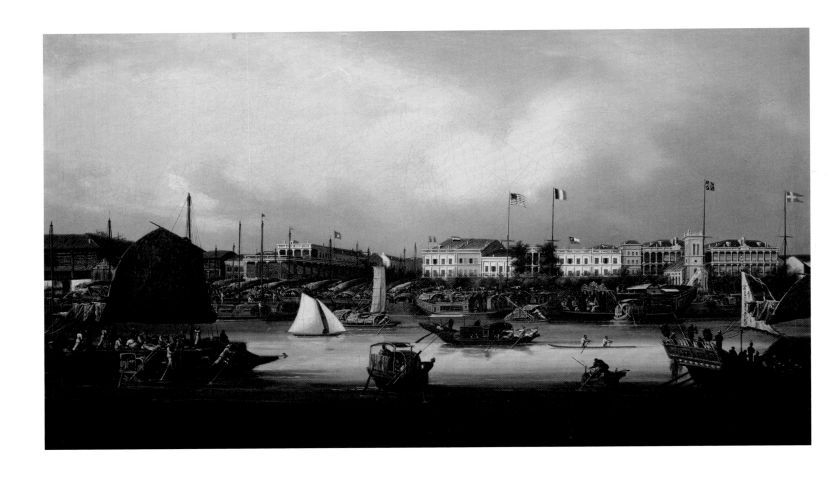

Unidentified Chinese artist, Canton, China, ca. 1855, oil on canvas, 19 x 32½ in. (1954.590)

Canton (Guangzhou) was the center of China's trade with foreign nations until the 1840s. The Chinese restricted foreign traders to a small section of the city, where they worked and lived in buildings called factories or "hongs." Negotiating through influential Chinese hong merchants, they sold their goods and purchased tea and other Chinese products, which were sent downriver to the waiting merchant ships. As trade expanded, opium took on increasing importance among the few outside goods of economic importance to the Chinese. When Chinese authorities attempted to stop the trade in opium, war erupted between China and Great Britain. As a condition of peace, Britain required the opening of five treaty ports, including Shanghai, and established the British colony of Hong Kong. By the 1850s these other ports, and especially Hong Kong, had replaced Canton as the entrepôts for trade with China.

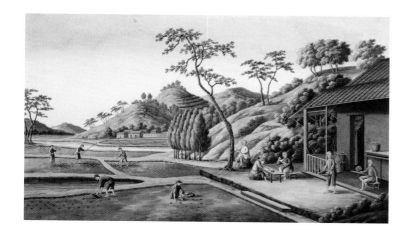
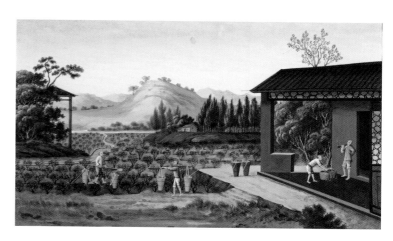
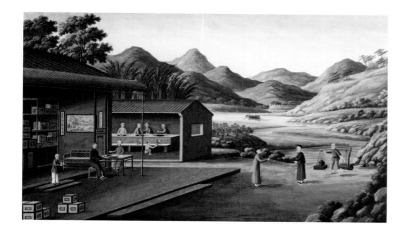
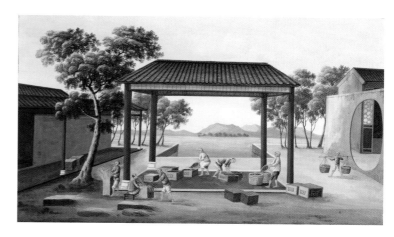

All, attributed to Tinqua, ca. 1850, watercolor and gouache, 7⅜ x 12½ in.
(top left) tea planting (1970.40); (top right) watering tea plants (1970.41); (bottom left) cured tea (1970.48);
(bottom right) loading tea into boxes (1970.49)

Active from 1840 to 1870, Tinqua was a prominent Chinese artist who painted scenes such as this series show-
ing the process of tea production, and American ship portraits for the American market.

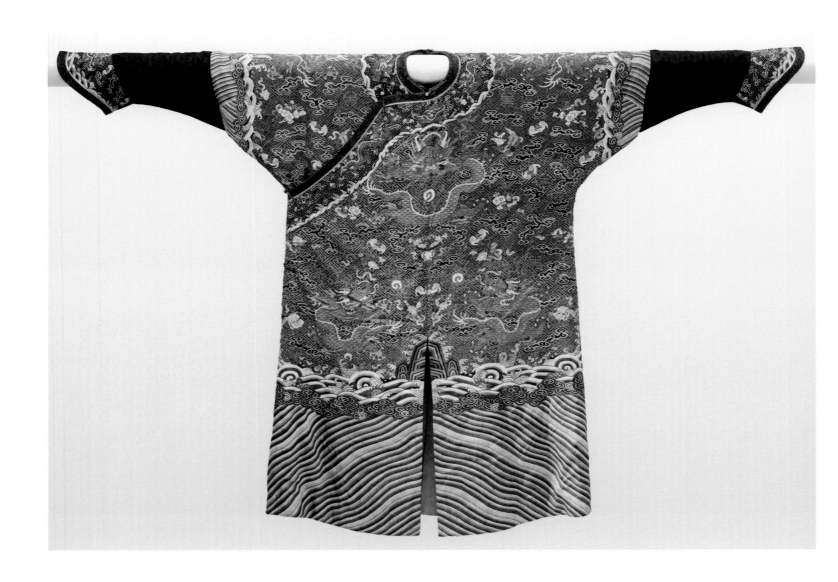

Unidentified artist, mandarin robe from Manchu Dynasty (1644–1912), silk. (1958.646)

Many exotic items came to the United States through maritime trade, either as curiosities or in commercial exchange. Made for a horseman, this Mandarin robe of the Manchu Dynasty has a split to permit riding a horse as well as horse hoof sleeves and cuffs which turn back when the wearer shoots an arrow. This piece was donated by the Museum's then education director, Marion Dickerman, a noted educator and long-time friend of Eleanor Roosevelt.

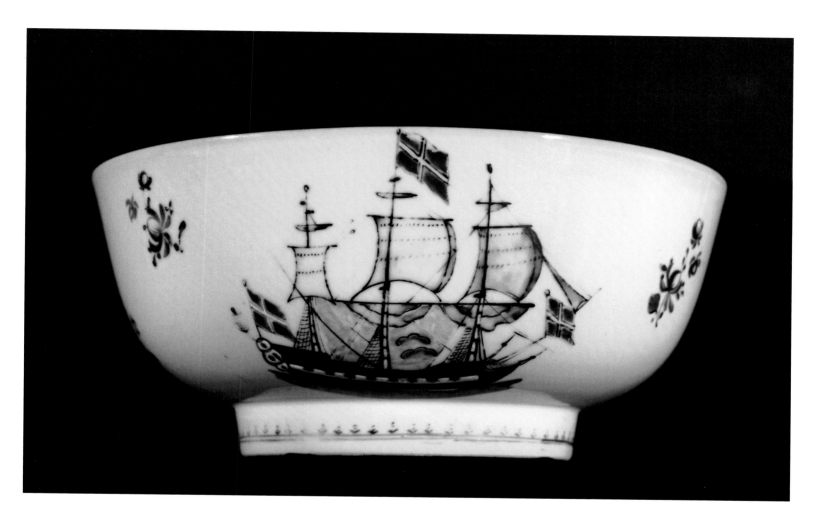

Unidentified artist, Chinese porcelain punch bowl, 1785, height 2½ in., diameter 6½ in. (1938.77)

Direct trade between America and China began in 1784 when the ship *Empress of China* left New York for Canton, carrying lead, lumber, cotton cloth, ginseng, and silver specie. A year later she returned to New York with a cargo of tea, silks, and porcelain, as well as this punch bowl, which had been purchased by the ship's carpenter, John Morgan, who died on the return passage.

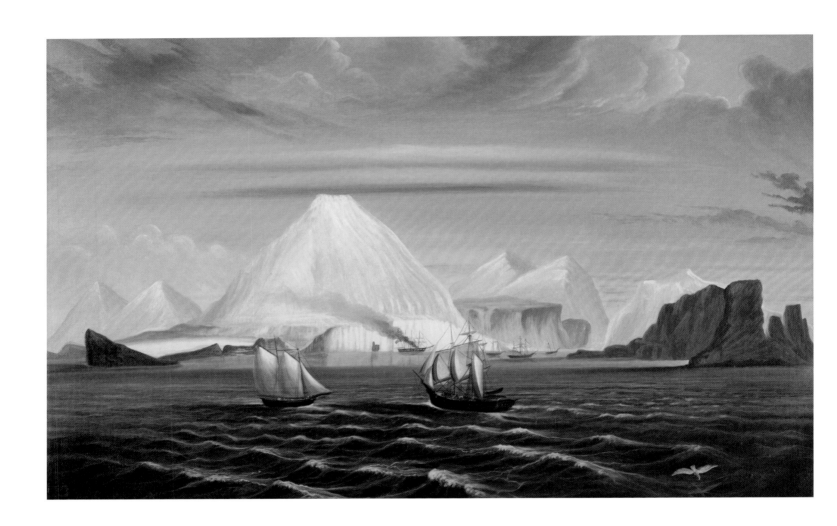

Unidentified artist, *Desolation Island, Indian Ocean*, ca. 1880, oil on canvas, 20 x 32 in. (1939.1265)

Desolation or Kerguelen Island lies in the subantarctic zone of the Indian Ocean. The hundred-mile-long volcanic island, with its deeply indented coast and numerous peninsulas, capes, and fjords, was a convenient base for whalers and sealers from New London, Connecticut, who came seeking right whales and elephant seals from the 1840s to the 1880s.

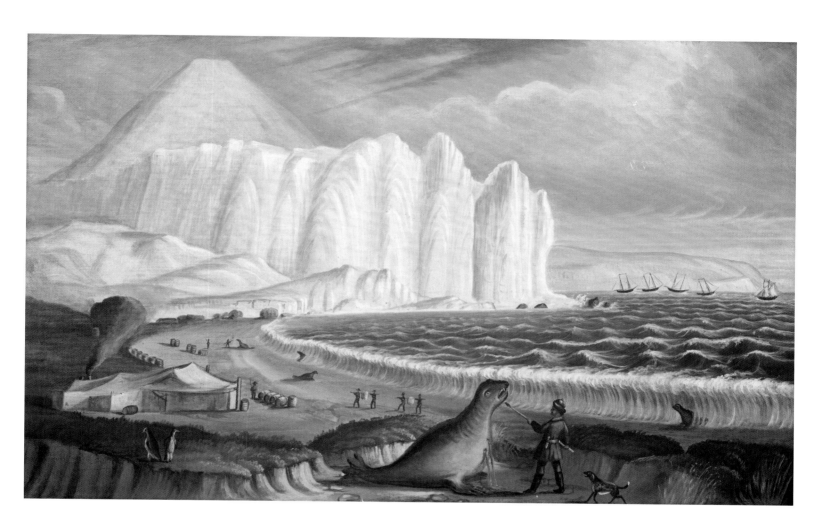

Unidentified artist, *Heard Island, South Indian Ocean*, ca. 1880, oil on canvas, 20⅛ x 32 in. (1939.1256)

Furs and oil lured American sealers and whalers to some of the remotest regions of the earth. Among these forbidding environments was Heard Island, located near the Antarctic Circle in the south Indian Ocean. Where glaciers fell into the frigid sea, elephant seals gathered to breed. Humans discovered the island in the 1850s, and for 30 years whalemen from New London, Connecticut, flocked there to kill these large beasts, rendering their insulating blubber into oil and saving their leathery pelts for industrial uses.

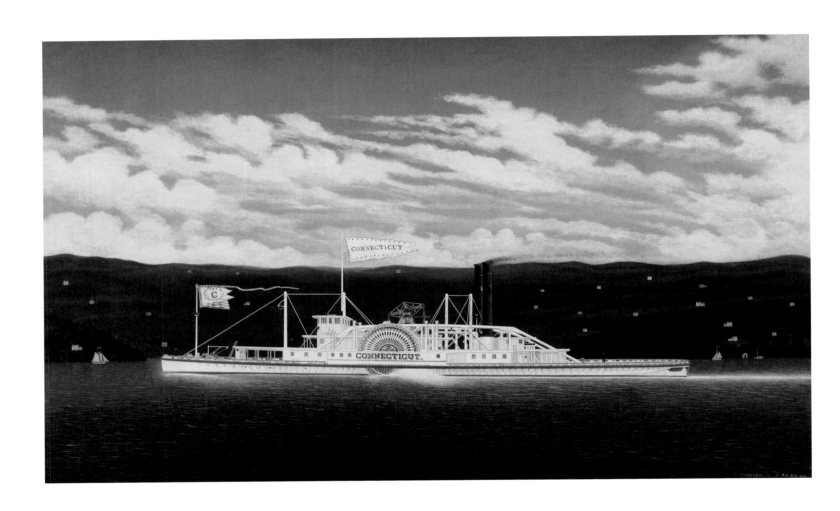

James Bard, side-wheel steamboat *Connecticut*, 1873, oil on canvas, 34 x 56 in. (1995.119)

James Bard (1815–1897), a self-taught New York marine artist who originally worked with his twin brother, carefully measured vessels before painting them, which resulted in very flat, almost folk-style renditions that are highly accurate to scale.

Built at New York in 1848, the side-wheel steamboat *Connecticut* was originally an elegant Long Island Sound passenger steamer. When Bard painted her, she had been altered to serve as a towboat on the Hudson River.

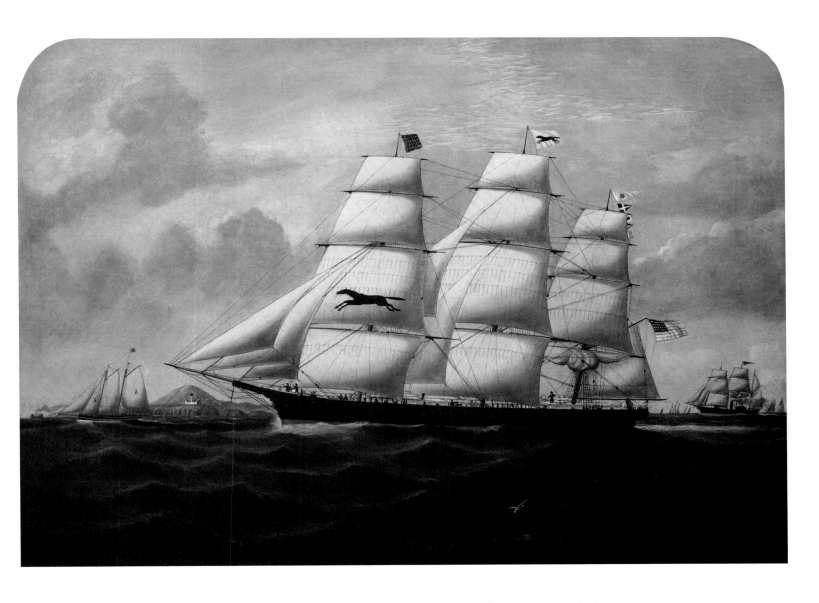

William G. York, *Ship 'Galatea' of Boston 1041 tons Regester off point Lynus March 5th 1862
Captain George B. Wendell*, 1862, oil on canvas, 25⅞ x 35¼ in. (1943.1156)

William G. York (1817–ca. 1883) was a shipwright turned marine artist. Born in St. John, New Brunswick, he worked in Liverpool from about 1853 until he moved to Brooklyn, New York, in 1871.

At the end of a four-and-a-half-month passage from San Francisco, Captain George Blunt Wendell was relieved to bring his fast but leaky clipper ship *Galatea* safely into Liverpool. While she was being repaired, he commissioned local marine artist William G. York to paint the ship's portrait, which cost five pounds with frame. The image is true even to the 30-foot running-horse symbol of the owners, William F. Weld & Company of Boston, which Captain Wendell had painted and attached to the foresail during the passage. Launched by Joseph Magoun at Charlestown, Massachusetts, in 1854, the 182-foot *Galatea* spent 20 years in the California and China trades for the Welds. Captain Wendell gave up command of the *Galatea* and retired ashore in 1863 when he arrived in New York to discover that his young daughter had died during his absence.

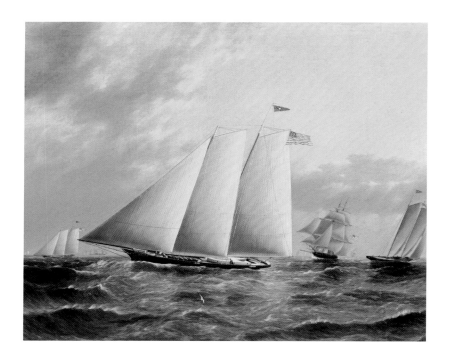

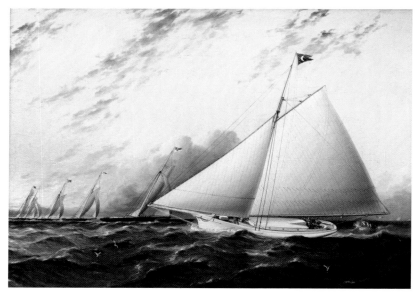

(top) James E. Buttersworth, schooner yacht, possibly *America*, ca. 1855, oil on canvas,
27 x 34⅚ in. (1949.3175)

This schooner yacht flying the burgee of the New York Yacht Club has been identified as the *America*, but her deck details differ from those of the *America*. She represents the sleek, heavily rigged yacht design inspired by the *America*'s victory over the Royal Yacht Squadron in 1851.

(bottom) James E. Buttersworth, sloop *Haswell* in New York Yacht Club Race, June 3, 1858, ca. 1859, oil on canvas, 12 x 16⅛ in. (1948.957)

A likely example of a commissioned yacht portrait, this small painting celebrates the victory of the sloop *Haswell* in a New York Yacht Club race just a week after she was launched. Buttersworth depicted her rounding Southwest Spit buoy far ahead of her competitors. The 50-foot sloop was built at Mystic, Connecticut, for Charles H. Mallory, a mariner and successful maritime businessman from Mystic who designed his own yacht.

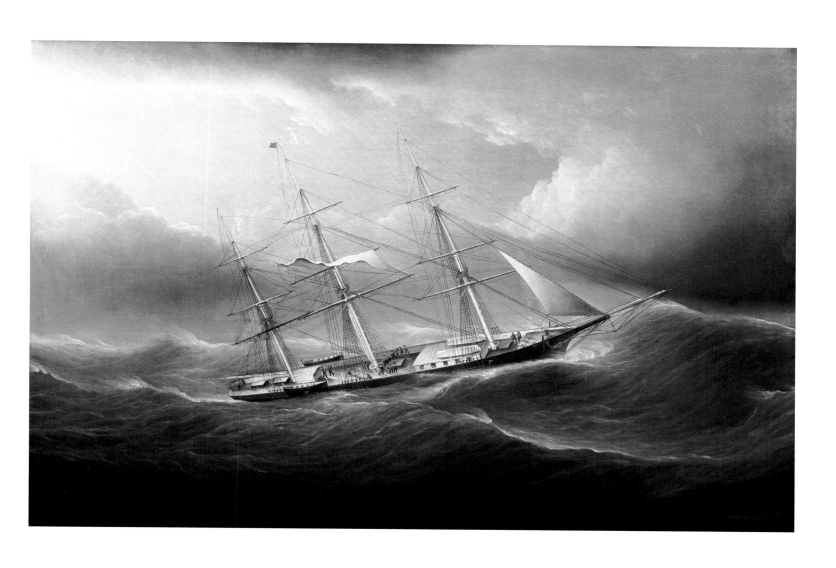

James E. Buttersworth, ship in a gale, ca. 1855, oil on canvas, 19½ x 29½ in. (1949.3176)

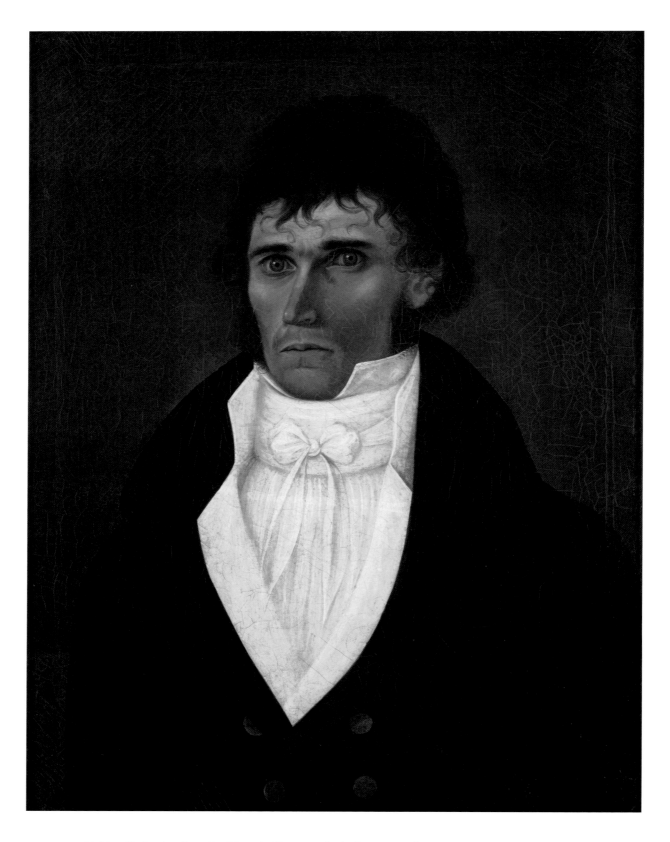

Unidentified artist, *Portrait of Captain Simeon Haley*, before 1846, oil on canvas, 24 x 18½ in. (1941.266)

Simeon Haley (1781–1859), captain of the schooner *Sally Ann*, was one of the defenders of Stonington, Connecticut, during the British attack on the port in 1814.

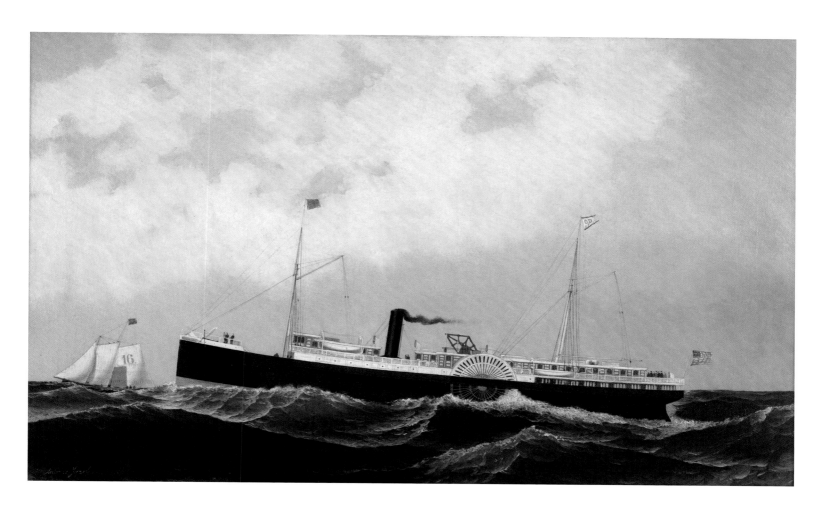

Antonio Jacobsen, *Old Dominion*, 1876, oil on canvas, 21¼ x 35½ in. (1959.65)

Antonio Nicolo Gasparo Jacobsen (1850–1921), a Danish-born marine artist, arrived in New York in 1871. Probably the most prolific American marine artist, he painted hundreds of vessel portraits during a forty-year career.

Built at Wilmington, Delaware, in 1872, the iron-hulled side-wheel coastal steamship *Old Dominion* provided regular passenger and freight service between New York and Virginia. Jacobsen's painting shows her picking up a pilot boat off New York.

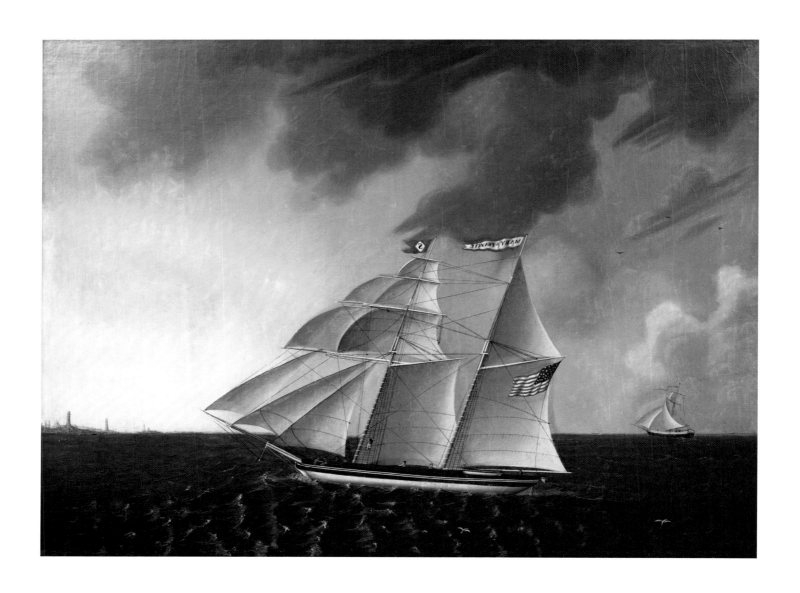

Unidentified artist, *Mary and Frances*, 1843, oil on wooden panel, 27⅛ x 35¹⁵⁄₁₆ in. (1962.1153)

This is believed to be the 92-foot topsail schooner *Mary and Frances*, built at Baltimore in 1832 and registered at New Orleans in 1835.

Conrad Freitag, pilot schooner *David Carll*, No. 4, ca. 1876, oil on canvas, 22⅝ x 34½ in. (1954.1605)

The German-American artist Conrad Freitag (1843–1894) was in New York by 1860 and served in the Civil War before taking up his career as an artist. He exhibited his work at the National Academy and the Brooklyn Art Association in the 1870s and 1880s. As a marine artist, he is best known for his skillful depictions of New York pilot schooners like this one.

Named for the City Island, New York, shipbuilder who constructed her, the 103-foot schooner *David Carll* was launched in 1876. In competition with other pilot schooners, she ranged far out into the Atlantic to encounter ships bound for New York and offer the services of a pilot to guide them safely into port.

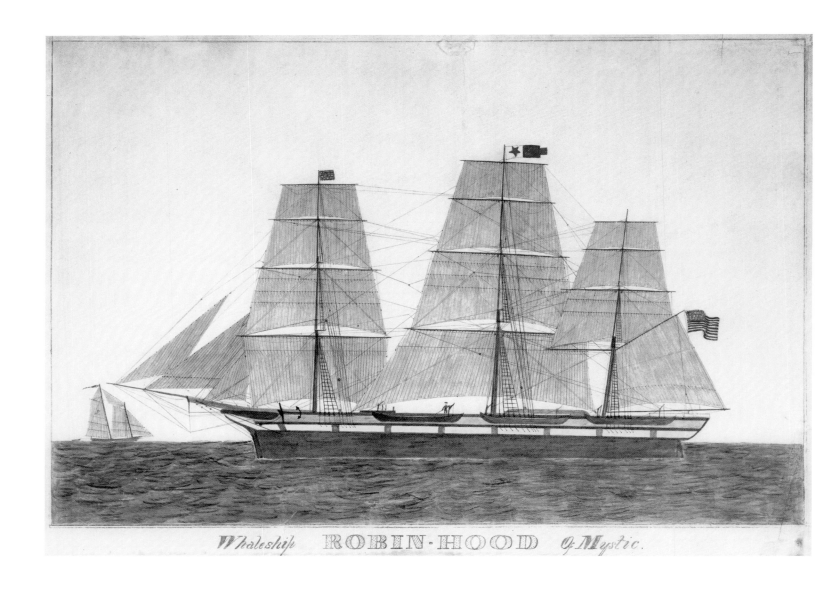

Whaleship ROBIN-HOOD *of Mystic.*

Unidentified artist, sail plan for whaling ship *Robin Hood*, n. d.,17⅛ x 24¼ in. (1958.1433)

The Mystic, Connecticut, whaleship *Robin Hood* was built in 1824 as a merchant ship and converted for whaling in 1845, making six voyages for Charles H. Mallory before being sacrificed as part of the "stone fleet" sunk in an attempt to block the harbor of Charleston, South Carolina, during the Civil War.

O. E. Potter, *Neptune's Car*, n. d., pen and pencil drawing with pastel, 15¾ x 19¾ in. (1948.28)

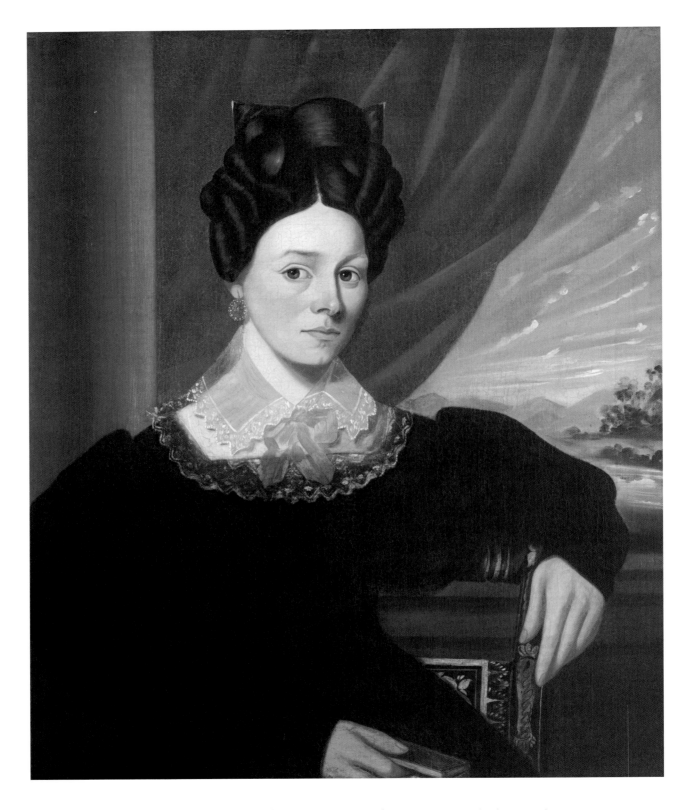

Isaac Sheffield, portrait of a woman, ca. 1840, oil on canvas, 36 x 31 in. (1950.1491)

With its red velvet curtain, outdoor background, and awkwardly depicted hands, this portrait has the characteristics of works by the itinerant Connecticut portrait painter Isaac Sheffield (1798–1845), who settled in New London in 1838. The model is thought to be the wife of the New London whaling captain shown opposite. Her fashionable dress and hairstyle date to the 1840 period.

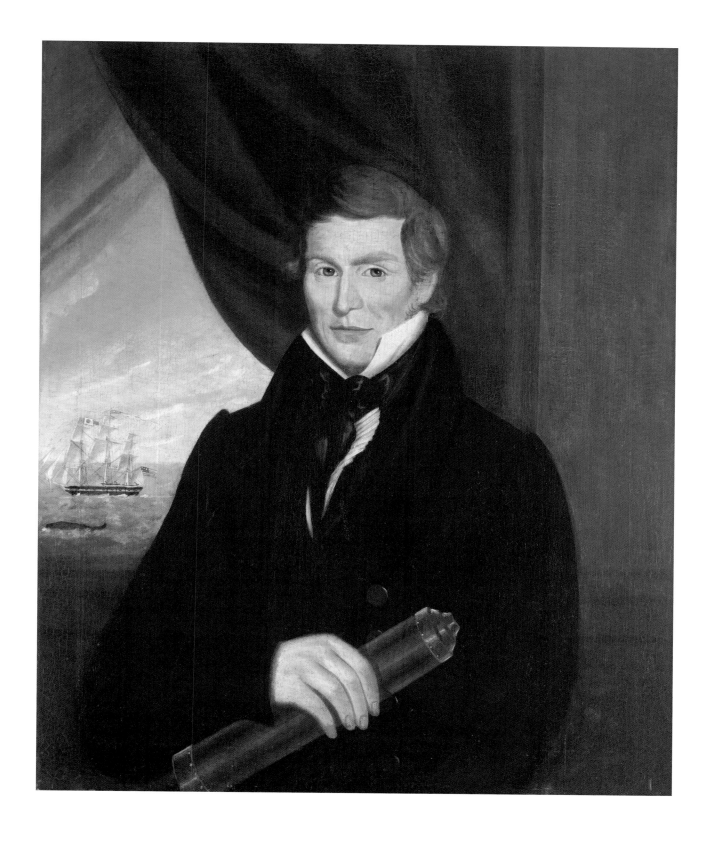

Isaac Sheffield, portrait of an unidentified shipmaster, ca. 1840, oil on canvas, 36 x 31 in. (1950.1490)

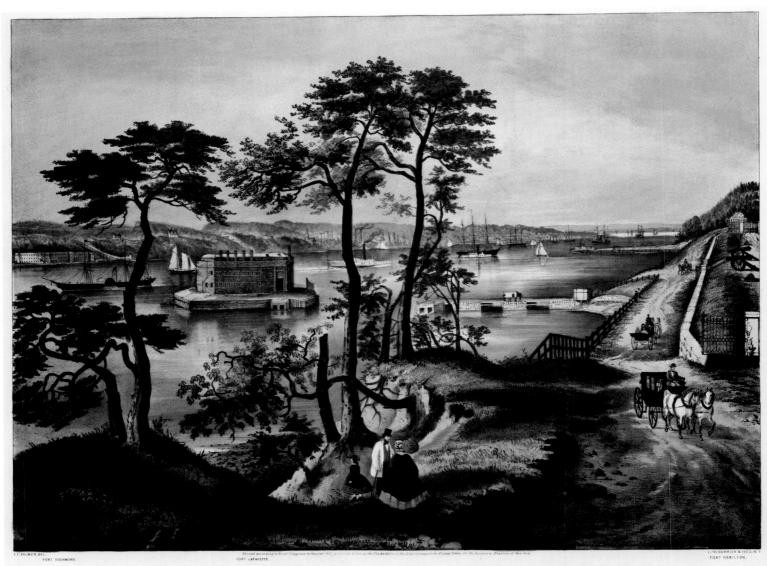

STATEN ISLAND AND THE NARROWS.

FROM FORT HAMILTON.

New York, Published by Currier & Ives, 152 Nassau St.

Frances Palmer for Currier & Ives, *Staten Island and the Narrows*, ca. 1855, lithograph (1954.186)

Frances Flora Bond "Fanny" Palmer (ca. 1812–1876) arrived in New York from England with her husband and their children in the early 1840s and by the 1850s was supporting the family as a "delineator" for Currier & Ives, creating wash drawings that the lithographers would reproduce on stone for mass-production prints. Her name appears on many Currier & Ives lithographs, both maritime scenes and landscapes.

Where the Verrazano Narrows Bridge now crosses from Brooklyn to Staten Island, Frances Palmer created a bucolic scene of the Brooklyn shoreline and the defensive fortifications that guarded access to New York Harbor.

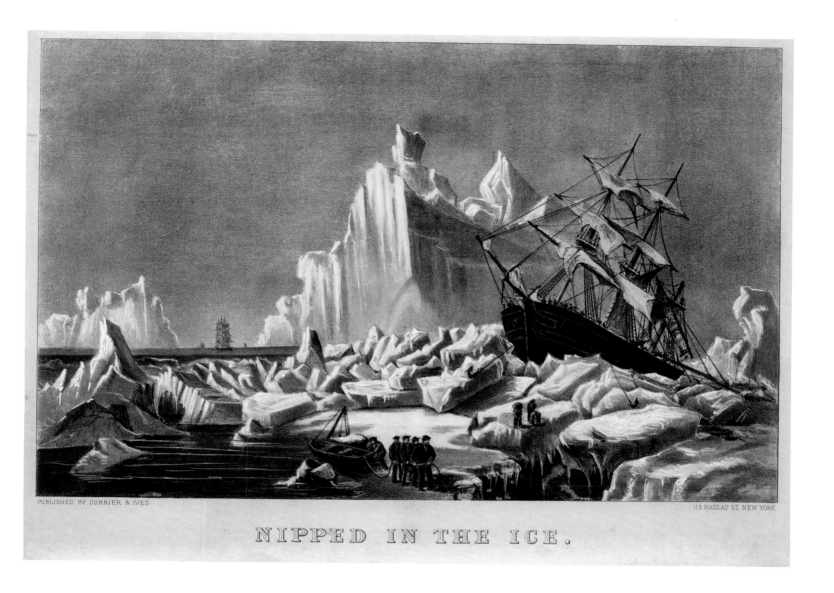

NIPPED IN THE ICE.

Currier & Ives, *Nipped in the Ice*, ca. 1877, lithograph, 10⅞ x 14 in. (1949.3249)

This dramatic scene of a doomed ship, caught in the ice of the eastern Arctic, is taken from a painting attributed to the artist William Bradford (1823–1892), who made several trips to Labrador and Greenland in the 1860s to capture the cold grandeur of the region.

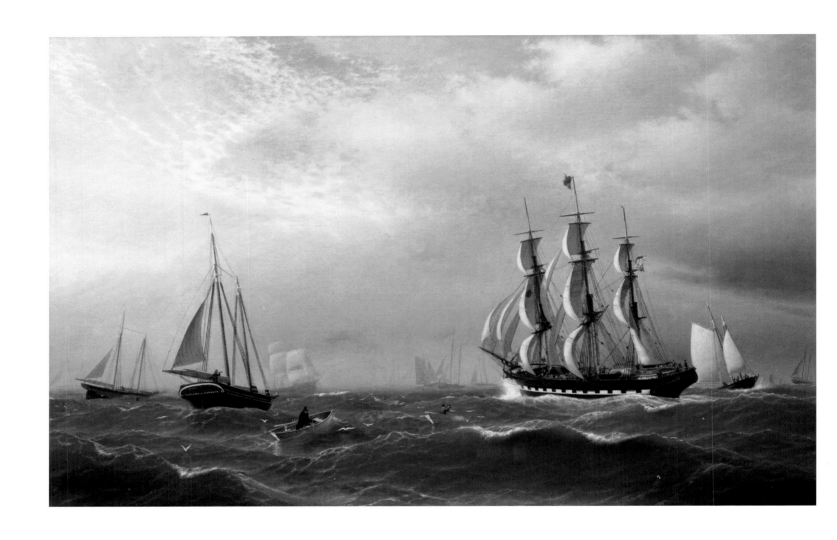

John E. C. Peterson, ship *Neptune* and schooner *Margaret*, 1866, oil on canvas,
36¹⁵⁄₁₆ x 56¹⁵⁄₁₆ in. (1958.626)

John E. C. Peterson (1839–1874), a native of Denmark, was active in Boston as a marine artist and illustrator
for *Harper's Weekly* by 1865.

 As an immigrant himself, Petersen may have crossed the Grand Banks of Newfoundland just as he
depicted the Black Ball Line packet ship *Neptune* doing in this stirring painting. With New England fishing
schooners plunging at anchor in the shallow seas, the 190-foot *Neptune* drives for New York with a group of
immigrants on deck. Launched in 1855, the *Neptune* stranded on Sable Island during this same run in 1876.

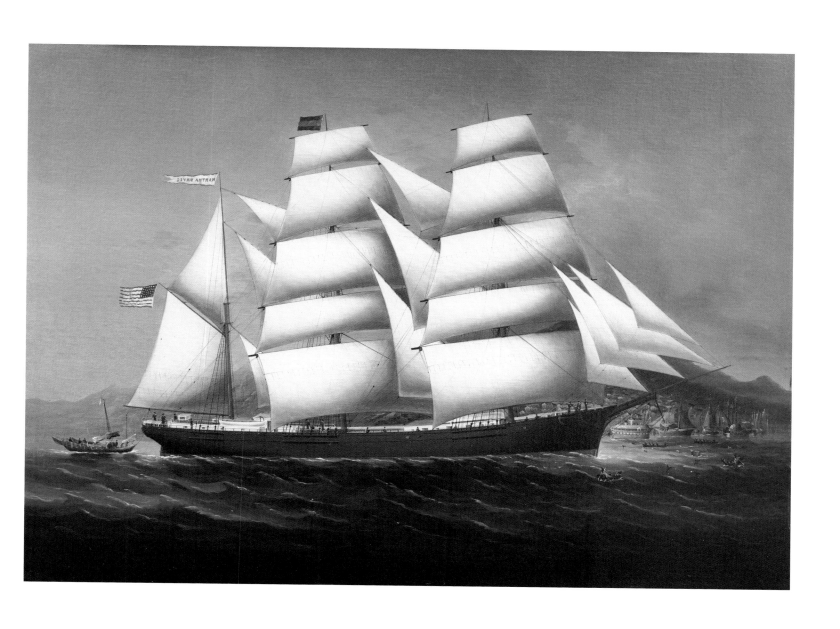

Unidentified Chinese artist, bark *Martha Davis* off Hong Kong, ca. 1880, oil on canvas,
23½ x 32½ in. (1985.103.2)

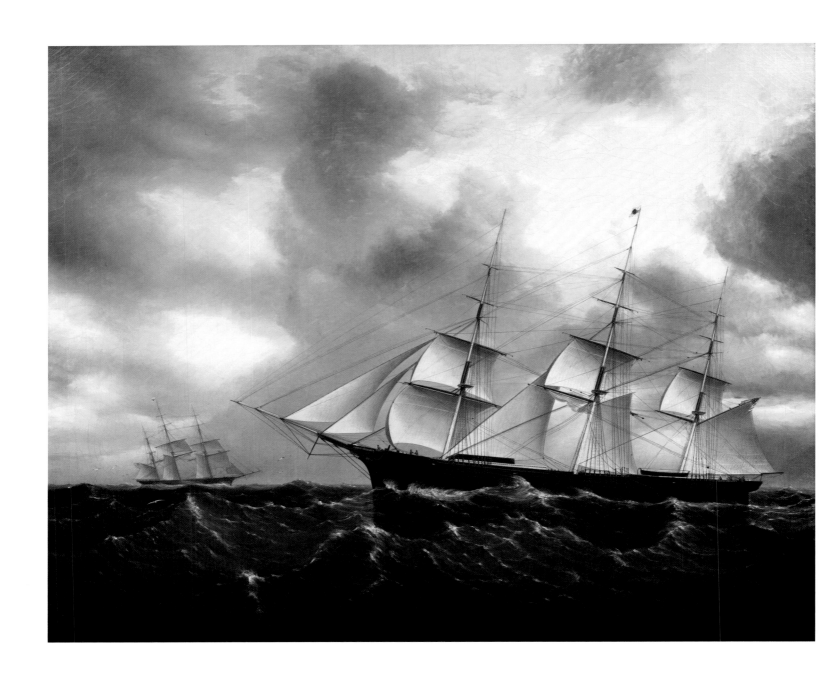

James E. Buttersworth, clipper ship *David Crockett*, ca. 1865, oil on canvas, 29 x 35½ in. (1992.21.10)

When he painted the 215-foot clipper *David Crockett*, launched at Mystic, Connecticut, in 1853, James E. Buttersworth depicted her under a balanced rig for storm conditions rather than under the cloud of canvas more typical of clipper ship images.

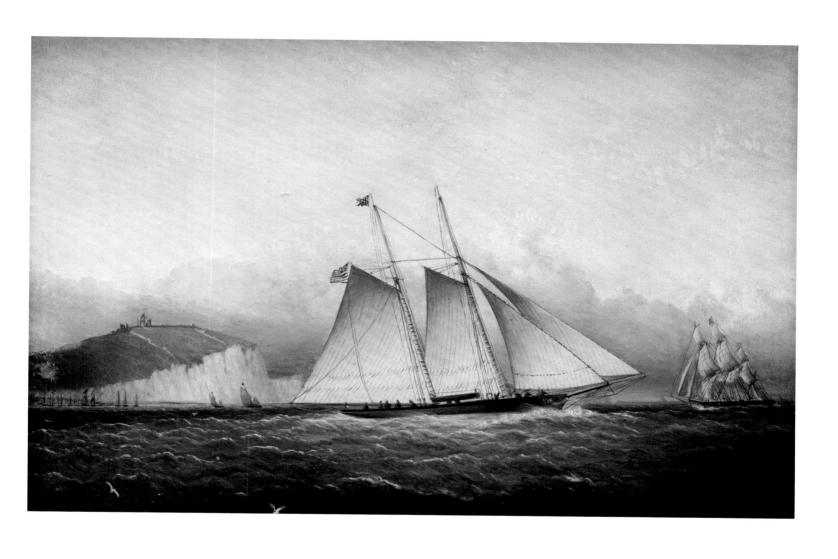

James E. Buttersworth, schooner yacht, possibly *America*, in the Strait of Dover, off England, ca. 1851,
7¾ x 11¾ in. (1963.461)

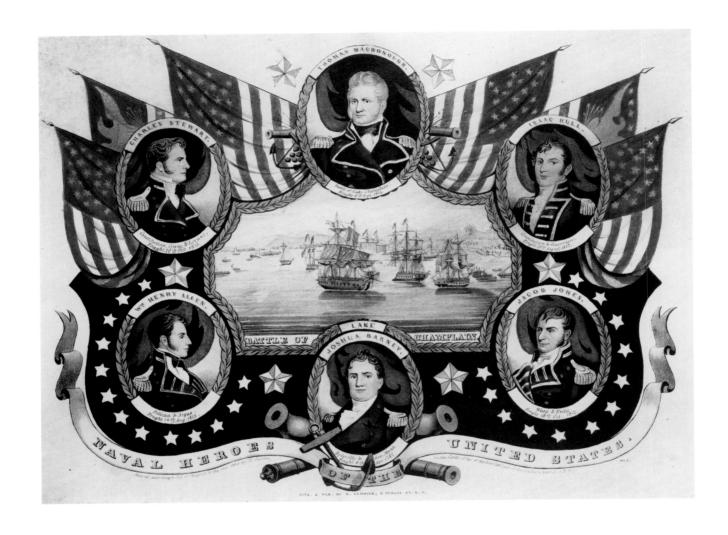

Currier & Ives, *Naval Heroes of the United States*, 1846, color lithograph, 10 x 14 in. (L.1959.1156)

Duncan McFarlane, packet ship *Samoset*, ca. 1851, oil on canvas, 24 x 36 in. (1970.8)

Of Scottish origins, Duncan McFarlane (1818–1865) was a skilled ship portrait painter active in Liverpool between 1848 and 1865. Many of his surviving works depict American ships.

The 136-foot American packet ship *Samoset* was launched at Portsmouth, New Hampshire in 1847. Here she approaches Liverpool in the stormy Irish Sea, passing one of the large wooden American transatlantic steamships of the Collins Line, which began service in 1850.

(top) Unidentified artist, American bark, ca. 1865, embroidered painting, 23¾ x 51½ in. (1965.706)

Probably made by a young sailor, this huge ship portrait is a spectacular example of yarn and embroidery work that has a long tradition among British and American mariners.

(bottom) Carolus Weyts, bark *Tycoon of New-York. Capt. John Lewey passing Flushing 1861,* reverse painting on glass, 22¼ x 28¾ in. (1984.71)

Carolus Weyts (1828–1876) specialized in ship portraits on glass at Antwerp.

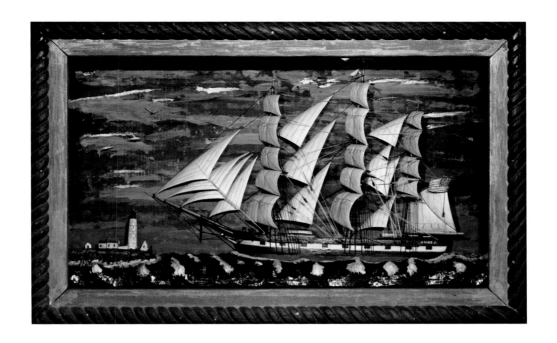

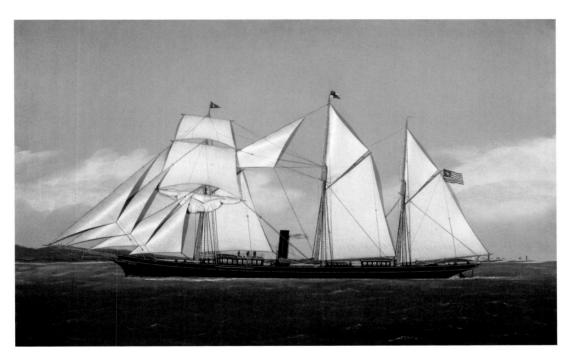

(top) Arthur Harwood, shadowbox model, *Annie J.*, 1920, 17 x 27 x 4½ in. (1953.3972)

Carved in low relief and decoratively painted, shadowbox models, a traditional form of sailor's folk art, could, like this one, be made with materials commonly found on board ship, and they were great gifts for family or friends back home. This example depicts a full-rigged American ship named *Annie J.* approaching the shore.

(bottom) Thomas Willis, *Sagamore*, ca. 1905, silk painting with oil on canvas background,
19½ x 31¾ in. (1959.1296)

Active from the 1880s to 1910, Thomas Willis (1850–1912) specialized in relief paintings of yachts with the vessels executed in silk, satin, and embroidery. The steam yacht *Sagamore* was launched at Bath, Maine, in 1888.

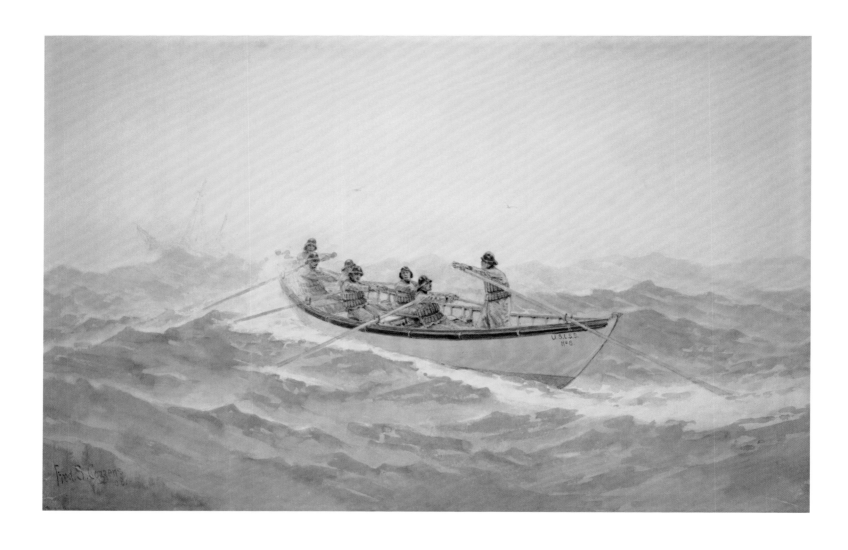

Frederic S. Cozzens, *U.S.L.S.S. #6 Rowing to the Wreck*, 1908, watercolor on paper board, 13 x 20 in. (1998.47.4)

Frederic S. Cozzens (1846–1928) was a popular marine artist and illustrator, many of whose works were reproduced as lithographs.

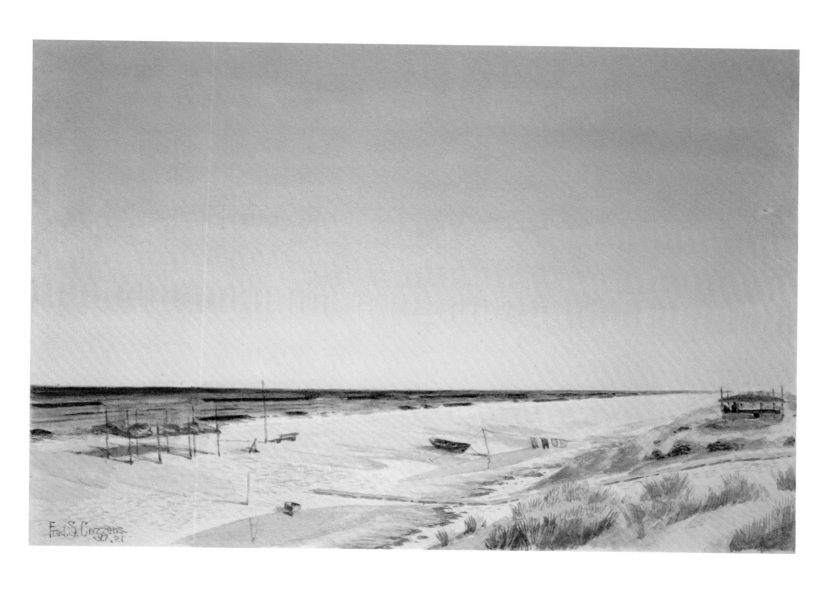

Frederic S. Cozzens, beach scene with drying racks, 1921, watercolor, 9½ x 14 in. (1998.47.14)

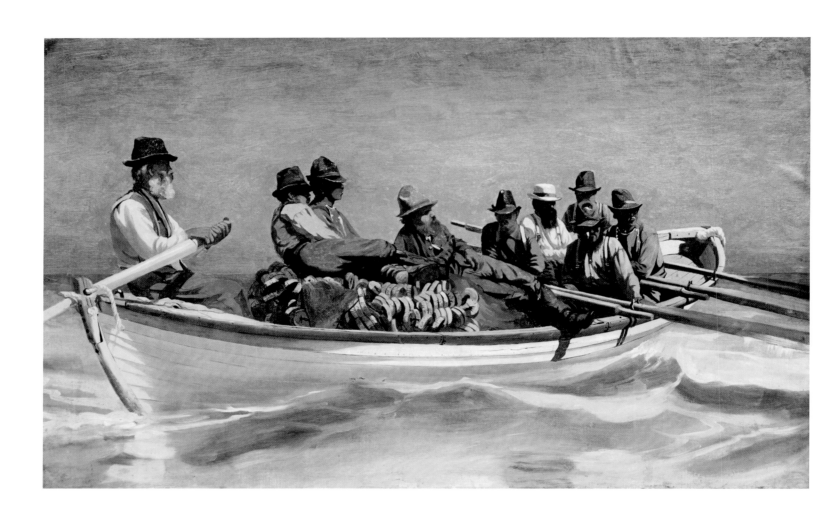

Milton Burns, waiting for the fish to school, ca. 1875, oil on canvas, 24¼ x 39 in. (1975.291)

Milton Burns (1853–1933) was a popular illustrator and artist active from the 1870s to the 1920s.
 This painting depicts a crew of mackerel seiners, possibly off Monhegan Island, Maine, waiting in their seine boat for the fish to show before rowing frantically around the school to set their net and capture the fish.

(top) Milton Burns, lobster fishing, n. d., pencil and ink wash, 5⅞ x 8⅞ in. (1986.122.20)

(bottom) Milton Burns, eel fishing (night), n. d., pencil and ink wash, 5⅞ x 8⅞ in. (1986.122.24)

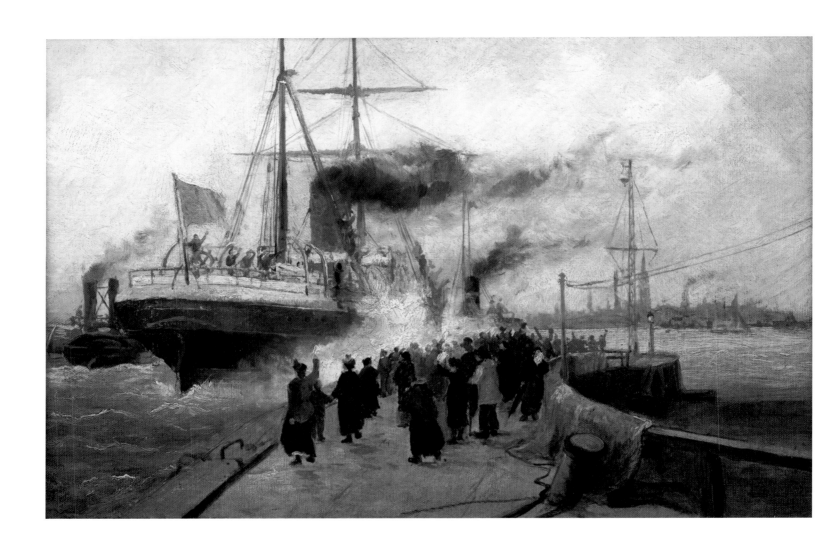

Ernest Beckett, emigrant ship leaving Liverpool docks, 1891, oil on canvas, 12 x 18 in. (1995.86.2)

Ernest Beckett was a Liverpool artist who exhibited at the Walker Art Gallery in 1905.

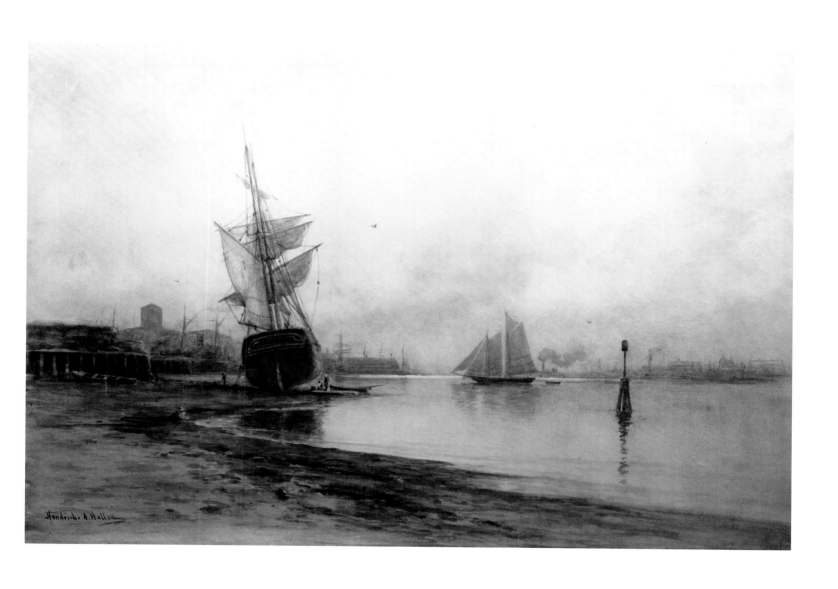

Hendricks Hallett, *Boston Harbor at Low Tide*, ca. 1880, watercolor, 19¼ x 28⅝ in. (1978.10)

Hendricks Hallett (1847–1921), a Boston artist, studied in Europe and was a member of the Boston Society of Water Color Painters.

PHOTOGRAPHS

Old photographs are often put away and forgotten in the attic, where summer heat and leaky roofs are their ruination. It is a very different fate for the more than one million photographs in the climate-controlled archives at Mystic Seaport. Here dedicated professionals preserve, catalog, interpret, and disseminate the imagery of this unique collection.

Indeed, the Museum's photography collection was begun in 1930, before the institution was six months old. However, it grew most dramatically in the 1970s and 1980s, with the acquisition of several sizable collections, including the million-image Rosenfeld Collection.

When considering a collection of historic photographs one must ask, why do photographs look the way they do? Photography combines a disparate chain of components. Each component affects the final photograph.

Photographs come from a camera, a device whose lens brings the physical world into focus on a light-sensitive plate or film. The resulting image is either a unique positive (a daguerreotype, for example) or a negative, from which paper prints are produced. Each process has its own signature look.

The photographer puts his mark on the image by the many choices he makes. First, a subject is selected and the camera is positioned to best advantage. The photographer then edits the rough work, deciding what images to present. Finally, he crafts the print or cased image.

Through our observation and contemplation of the image, viewers might be considered the final link in this creative chain. Even the viewer's perspective affects the meaning of a photograph.

Many links in this chain are set. This was especially true in the first decade of photography in the 1840s. In that era, the daguerreotype was the only commercially viable process. This process resulted in an image composed of tiny drops of mercury on a silver-plated sheet of copper. The unique mirrored image was metaphorically described as "delicate as the wing of a butterfly." Accordingly, they were sold in protective glass-covered brass mats, housed in book-like cases. Materials were obtained from suppliers in standardized sizes. Photographers (then called operators) followed the instructions and produced a standardized product. Occasionally, portraits were embellished. Rouge was added to the sitter's cheeks, or gold added to accentuate an object in the portrait, such as a locket or telescope. With only the precedent of painted portraits, early daguerreotypes imitated paintings, using drapes for backdrops and sometimes posing the sitter with the tools of his trade. Daguerreotypes are rich, beautiful, and nearly three-dimensional. In hindsight it seems unlikely that the medium of photography would have commenced from such a complicated process. The daguerreotype process was not to last.

Bolles & Frisbie, Antoine DeSant, ca. 1880, tintype, 8½ x 6 in. (1992.119.1)

Antoine DeSant (ca. 1815–1886) was a black Cape Verdean who apparently arrived in New London, Connecticut, in the 1830s aboard a whaleship and made several whaling voyages in the 1830s and 1840s before settling in New London.

By the mid-1850s light-sensitive silver salts became the foundation of photography, a technology which continues to this day. A salt silver emulsion was the basis for the glass-based ambrotype, a process that mimicked the daguerreotype's presentation, and displaced it by costing less. As with the daguerreotype, ambrotypes and their less expensive cousin the tintype (with the silver emulsion on a thin sheet of iron), were almost exclusively portraits. As cased portraits became more common, non-standard, vernacular presentations were created. Still, the camera was rarely taken out of the studio. Thus, when a cased ambrotype of a Great Lakes side-wheel steamer like the *Michigan* appears, it is worth noting (page 59).

The next step in the evolution of the medium was the wet-plate negative. From the negative, multiple paper prints could be made. These inexpressive multiples dealt the deathblow to all cased images. Though unwieldy and slow, the wet plate finally put the photographer in the field.

The 1880s brought the more light-sensitive, commercially standardized dry-plate negative. Accordingly, photographers went farther afield. It was especially challenging to photograph a galloping yacht, and for the first time this challenge was met. Marine photography became an area of specialization, and the Museum's Rosenfeld Collection, whose images date to as early as 1881, contains some of the finest examples (pages 78–83).

The improved dry plate also expanded how a scene was considered. Rather than being completely subject-oriented, a pictorial approach representing a more artistic perspective could be utilized. George E. Tingley's photograph of a fully laden hay scow (page 70) is well suited to platinum printing, rather than the conventional silver. Platinum emphasizes a delicate grey scale with subtle light and reflection. These features create an evocative scene.

At the turn of the century the introduction of flexible film truly made the camera available to the masses. Subject matter further expanded to encompass personal family activities and spontaneous views on the street or wharf, captured by talented amateur photographers.

Another of photography's roles was as a window on the world. Photographs of remote places added to the accounts sailors gave of their adventures. An especially poignant series of photographs was made aboard the whaler *Era* by Captain George Comer as she wintered over in Hudson's Bay. There, the Inuit assisted the *Era* by supplying fresh meat and sharing the skills needed to survive the long winter. Captain Comer, an amateur ethnologist, photographed the Inuit aboard the *Era* and going about their daily lives (page 74).

Photography has a unique ability to show the past. This was of little consequence early on, but as time passed old views took on new significance. This is illustrated in the comparison of two views of the Fulton Fish Market, made only about 50 years apart. In the 1865 albumen print on page 62, we see hundreds of people facing the camera, which is positioned up a story or two and pointed to show the stalls, each marked with the vendor's name. That so many people at such a distance from the camera would look up at the same moment is a testament to the photographer's ingenuity. Horses' heads, small sailboat masts, and impatient people are blurry as they moved during the exposure time of several seconds. Those who stood still are recorded in great detail. You can count the cobblestones or read a broadside posted on a building in the foreground. Meanwhile, on the street, wagons and the trolley are horse-drawn. In the harbor there are a few steamships, but sail dominates. The buildings are made of wood and a few appear to be somewhat rickety. The print is large—about 11 x 16 inches—which means the wet-plate negative from which it came was equally large. Also, the print is not exactly black-and-white. The dark areas are a brownish black and the highlights

are yellowish. The color is typical of an albumen print, the most common of the 1800s. Albumen, or egg white, is the basis for the light-sensitive emulsion with which this print is made.

A mere 50 years later, a photograph by Edwin Levick of the same subject (page 63) illustrates a markedly different world. Like his unidentified predecessor, Levick has climbed an adjacent building for an advantageous viewpoint. He has also brought a tripod-mounted view camera, though a smaller 8 x 10 inches, a size that is an industry standard. His dry plate is more light-sensitive so the shorter exposure time freezes moving people and vehicles in the street. Horses' heads are sharp. Wagons are less common than trucks. We are moving into the modern era, as evidenced by the smokestacks of a power plant and by the tall Singer Building in the cityscape behind the market. The market itself has been changed completely. Wood has given over to brick in every building. The location is the same, but with the passage of time this has become a very different place.

It has been said that the winners write the history books. Another manifestation of this phenomenon is of *what* was photographed. Portraits contain a disproportionate number of successful people. Of the objects in photographs, strutting yachts and commercially important vessels dominate the marine views. However, the camera, once aimed, is an indifferent observer and occasionally allows us a detailed, if inadvertent, view of the whole scene. A good example of this is the view of the steamship *City of Rome* on the New York waterfront (page 65). She dominates the view, but a close inspection reveals unassuming vessels, including barges and fishing schooners, and even teamsters working a wagon. Before 1900, photographs were made from information-packed large-format negatives. Negatives were the same size as the finished print because enlargement awaited the post-1900 invention of papers of greater light-sensitivity. There is a world of primary information to be gleaned from nineteenth-century photographs by a patient observer with a magnifying glass.

Early photography was even able to simulate three dimensions. By simultaneously making two negatives through two lenses placed the same distance apart as our eyes, then reviewing the resultant photographs through a stereo viewer, we can combine the images in our brain and experience the view in three dimensions. These stereo views became immensely popular during the Civil War era and remained so until superseded by newsreels in the early 1900s.

Since the dawn of the medium, the vast majority of photographs made have been of people. We make photographs to mark a milestone, or to have a likeness to present to a friend or loved one.

As time passes, the significance of a photograph changes. Personal photographs augment our memory of people and events gone by. But when enough time passes so that no one recalls the people or events depicted, then what? Many photographs now considered important historical documents originated as family photographs. We now consider these photographs in a new light. The individual is truly gone with the passing of their memory. Now the portrait becomes an object from which we can make deductions about styles of clothing, the status of the sitter, or the state of society. Our photograph has been transformed into an historic artifact.

We relate to photographs because we make and view them every day. We view photographs of the past with curiosity. We look at these images of long-ago maritime scenes and believe we can touch a past reality. One can only wonder: how will people know us through our photographs in the future?

NICHOLAS WHITMAN

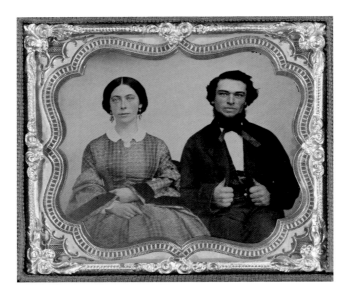

(top left) Unidentified artist, portrait of Captain John Bolles, ca. 1860, daguerreotype, 3¾ x 3¼ in. (1955.545)

(top right) Holmes, Booth & Hayden, portrait of Nancy Chapman Bolles, ca. 1860, ambrotype, 3⅝ x 3⅛ in. (1955.546)

Captain John Bolles (1820–1871) of Montville, Connecticut, made seven whaling voyages between 1845 and 1869. After his first voyage he married Nancy Chapman (1825–1910), and then sailed off for a two-year voyage to the Pacific. After he returned in 1850, it had become common for wives to accompany their whaling-captain husbands. Nancy joined John on the whaleship *Alert* and, pregnant, was left in Hawaii when John took the ship whaling in Alaska waters. During her three-year adventure Nancy saw the Cape Verde Islands, Pitcairn Island, Hawaii, the South Pacific islands, and Brazil. And by the time they all returned home from the Pacific, she and John had doubled the size of their family.

(bottom) Unidentified artist, portrait of Captain and Mrs. John Forsyth, ca. 1858, ambrotype, 3⅜ x 3⅞ in. (1967.26)

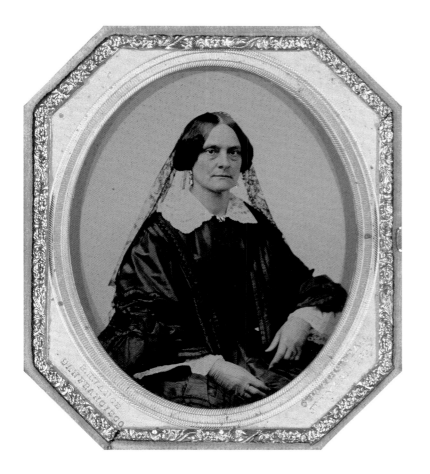 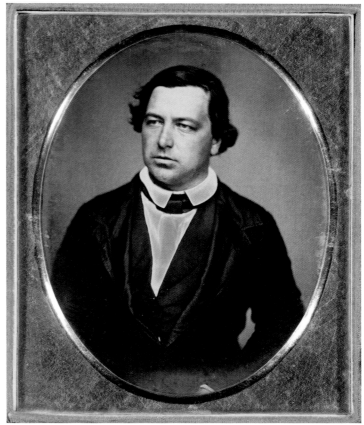

(left) Robert H. Vance, portrait of Mrs. Lucien Loeser, ca. 1857, ambrotype, 3 x 3¾ in. (1954.434)

Robert H. Vance (1825–1876) was born in Maine, learned the daguerreotyper's art in Boston, moved to Chile, and settled in gold rush-era San Francisco in 1850. A skilled photographer and entrepreneur, he operated a network of studios in northern California, Nevada, and even Hong Kong, before moving back east in 1865.

(right) Robert H. Vance, portrait of Lucien Loeser, ca. 1855, daguerreotype, 4½ x 3¾ in. (1954.435)

Lieutenant Lucien Loeser of the West Point class of 1842 was posted to duty in California in 1846. He was selected to travel to Washington in 1848 to deliver the news of the discovery of gold in California. Assigned to the 3rd U.S. Artillery, he and his wife were bound for California as passengers on the ill-fated steamer *San Francisco*, which foundered in a North Atlantic hurricane in December 1853. The Loesers were among the survivors who spent three days on the wreck before being rescued by another ship. They made it to California in 1854.

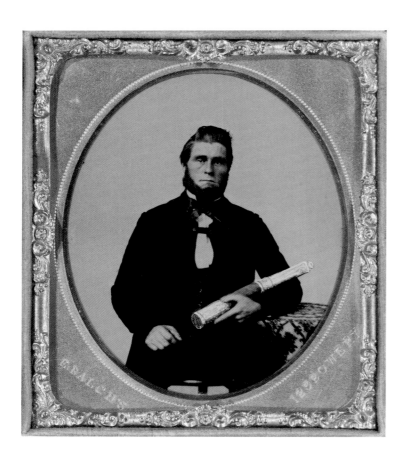 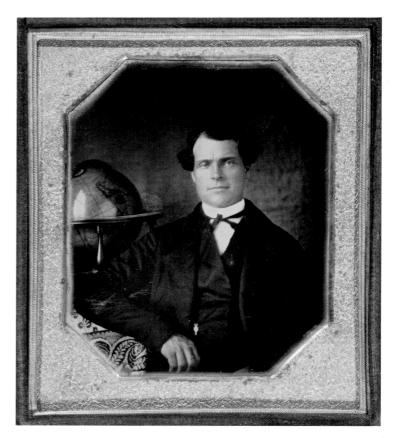

(left) E. Balch, portrait of James Russell Swift, ca. 1855, ambrotype, 3¼ x 2¾ in. (1979.30.2)

James Russell Swift (1823–1863) of New Bedford, Massachusetts, may have served on the schooner *Forest King* in the 1850s.

(right) David Pretlove, portrait, possibly of Nathaniel Brown Palmer, ca. 1848, daguerreotype, 3½ x 3½ in.(1996.7)

Captain Nathaniel Brown Palmer (1799–1877) of Stonington, Connecticut, was in command of a sealing schooner when he came upon the continent of Antarctica in 1820. This image resembles him, and the globe in the background is turned to show Palmer Land in Antarctica.

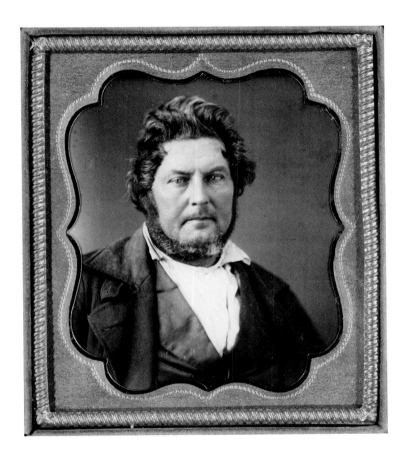

(left) Unidentified artist, portrait of a man, ca. 1852, daguerreotype, 3⅝ x 3¼ in. (1947.1659)

(right) Unidentified artist, portrait of New Bedford whaleman Isaac Bliss, after 1830, daguerreotype, 3⅝ x 3¼ in. (1997.90.2)

Unidentified artist, portrait of Captain Hubbard C. Chester, ca. 1855, daguerreotype,
4⅛ x 3¼ in. (1969.563)

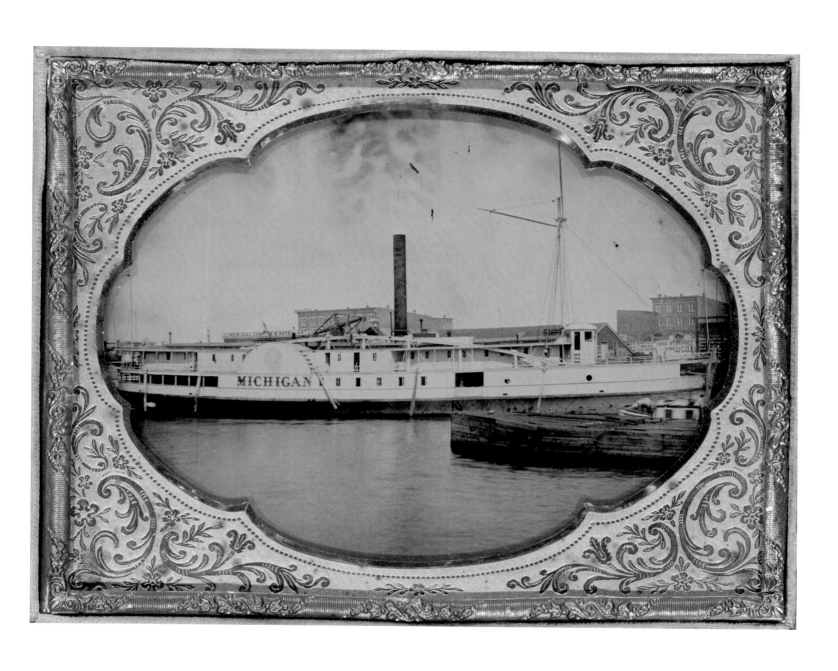

Unidentified artist, side-wheel steamboat *Michigan*, ca. 1855, ambrotype, 6 x 4 in. (1995.115)

Launched at Detroit in 1847, the 190-foot *Michigan* ran between Buffalo, Detroit, and Green Bay, Wisconsin.

(top left) Everett Augustus Scholfield, portrait of Addison Scholfield, ca. 1860, ambrotype, 1¹⁵⁄₁₆ x 1½ in. (1977.92.2B)

(top right) Unidentified artist, portrait of a boy, n.d., 2 x 1½ in. (1977.92.15)

(bottom) Holman, portrait of four men, ca. 1850, daguerreotype, 3¾ x 3¼ in. (1954.1601.45)

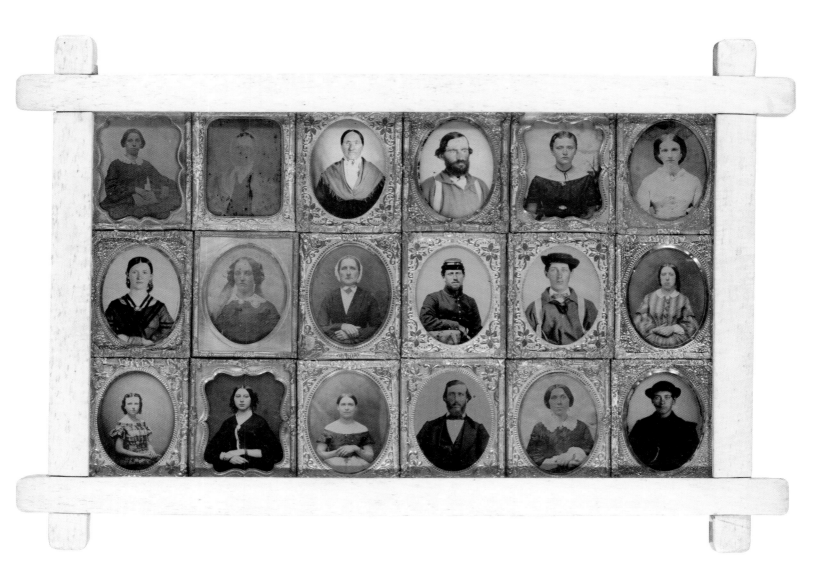

Unidentified artist, the Frederick Smith family, ca. 1864, eighteen tintypes in a white whalebone frame,
10⅛ x 15 in. (1941.294)

Shown in his Civil War uniform (center) Captain Frederick Howland Smith (1840–1924) went to sea as a cabin
boy of a whaleship at age 14. After rising through the ranks and serving in the army during the Civil War, he
commanded his first ship at age 29. He became captain of the bark *Ohio*, and his wife Sallie (top right) joined
him at sea after his first voyage. She kept a journal of their voyages as Frederick spent his days working and
making scrimshaw. Built in Rochester, Massachusetts, in 1833, the *Ohio* was lost in the Arctic Ocean in 1889.

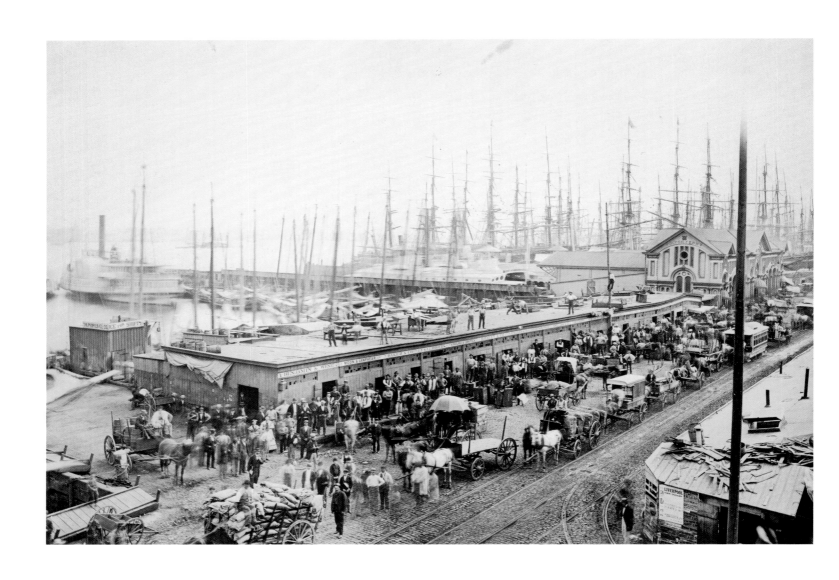

Unidentified artist, Fulton Fish Market, New York City, ca. 1868, albumen print, 10¾ x 15¹⁵⁄₁₆ in. (1964.47)

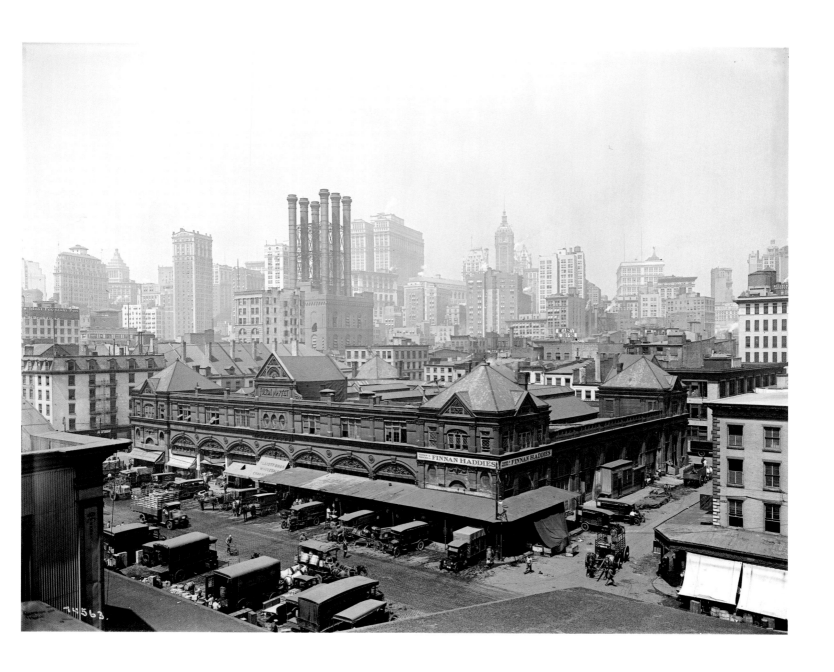

Edwin Levick, Fulton Market, New York City, ca. 1920, glass negative, 8 x 10 in. (1994.125.642)

Edwin Levick (1869–1929) arrived in New York from England in 1899 to work as a translator. He became a full-time journalist, then a professional photographer with his own studio by 1905, specializing in maritime photography.

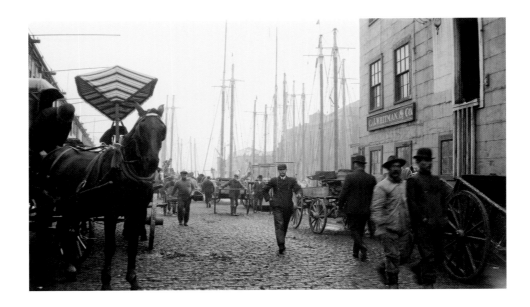

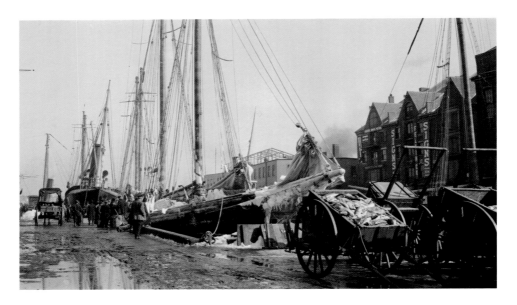

(top) Henry Donald Fisher, looking out from T Wharf, Boston, 1911, nitrate negative, 2⅞ x 4½ in. (1976.208.595A)

Henry Donald Fisher (1882–1961) was an amateur photographer with maritime interests who graduated from the University of Pennsylvania in 1904 and worked as an engineer in Boston between 1908 and 1920.

(bottom) Henry Donald Fisher, icebound schooner at T Wharf, Boston, 1911, nitrate negative, 2⅞ x 4½ in. (1976.208.639)

T Wharf was Boston's principal fishing wharf until 1914. In this view, a schooner believed to be the famous *Elsie* has just arrived, sheathed in ice. She is framed by a cart-load of cod or haddock for market and a harbinger of the coming technology in the form of a steel fishing trawler, a type of vessel that would supplant the schooners within 20 years.

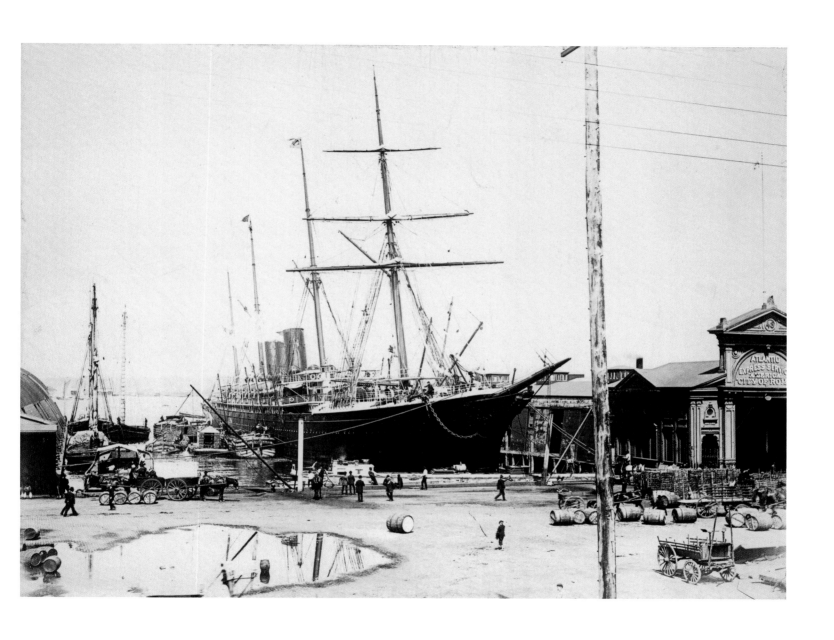

Unidentified artist, transatlantic steamship *City of Rome*, New York City, ca. 1890, albumen print,
5 x 7 in. (1990.50.57)

Unidentified artist, boat under construction at George Lawley & Son yard, Neponset, Massachusetts, 1915,
gelatin glass negative, 6½ x 8½ in. (1981.104.107)

Albert Cook Church, fishing dragger *Potomska* under construction, 1941, silver print photograph,
8 x 9¹⁵⁄₁₆ in. (1980.101.272)

Albert Cook Church (ca. 1880–1965) of New Bedford, Massachusetts, became the chronicler of the last days
of whaling and of the maritime life of New Bedford, publishing several books of photographs. His studio was
at the Pierce and Kilburn shipyard, where this fishing vessel was built in 1941.

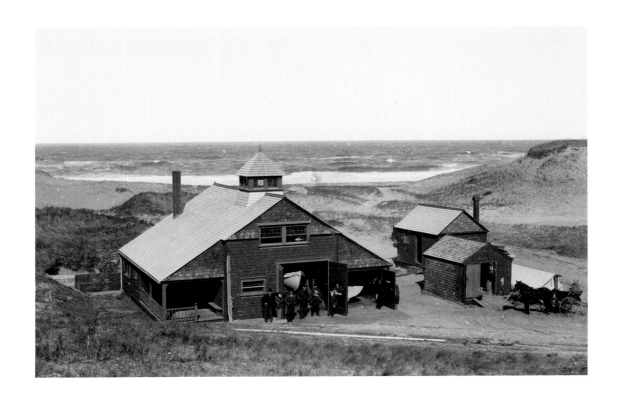

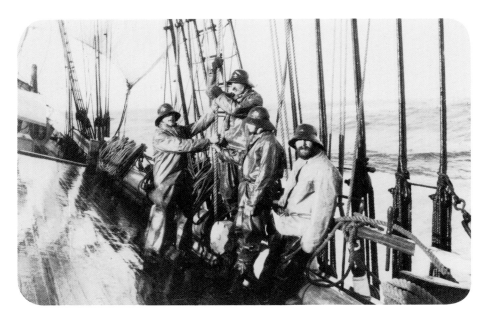

(top) C. N. Taylor, *View of the Highland Life Saving Station*, 1897, albumen photograph,
4⁷⁄₁₆ x 6¾ in. (1978.72.2)

Commercial photographer C. N. Taylor of Provincetown, Massachusetts, produced a series of cabinet photographs of local Cape Cod scenes, including this U.S. Life-Saving Service station and crew in Truro.

(bottom) Unidentified artist, sailors on deck, bark *Alice*, ca. 1900, albumen photograph,
2½ x 3½ in. (1996.113.1.11)

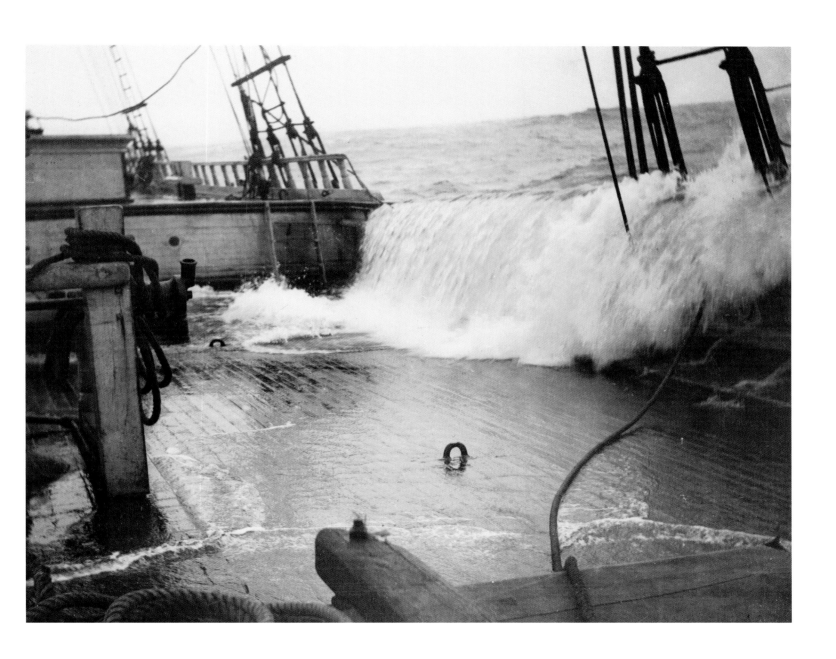

Unidentified artist, sea washing over deck, photograph, 7⁷⁄₁₆ x 9½ in. (1980.120.77)

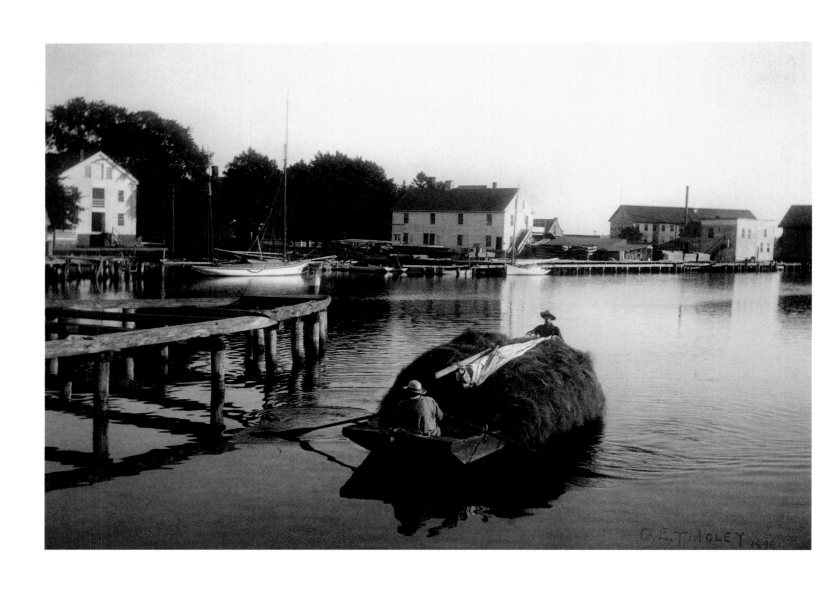

George E. Tingley, a load of marsh hay on the Mystic River, 1899, platinum print, 4½ x 6½ in. (1976.124)

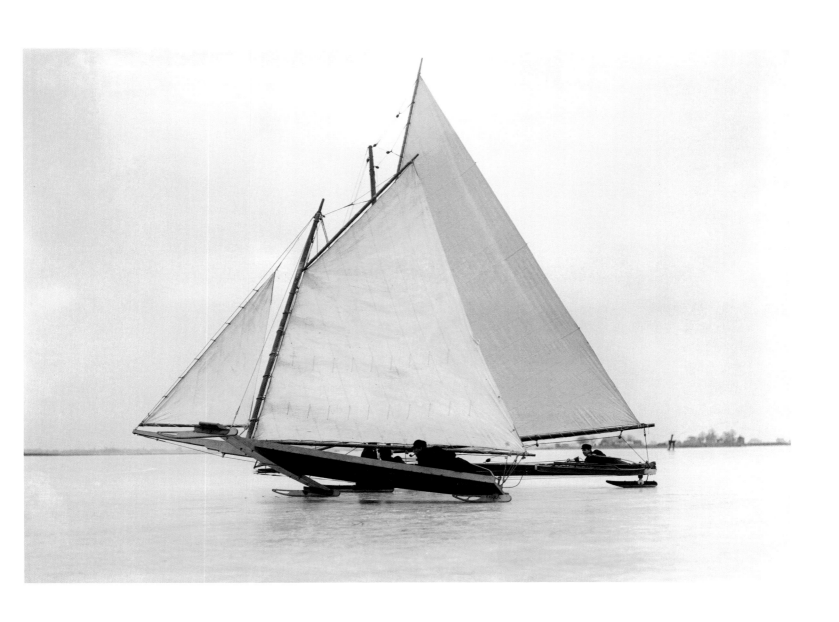

Edwin Levick, iceboat race, n. d., glass negative, 6½ x 8½ in. (1994.125.741)

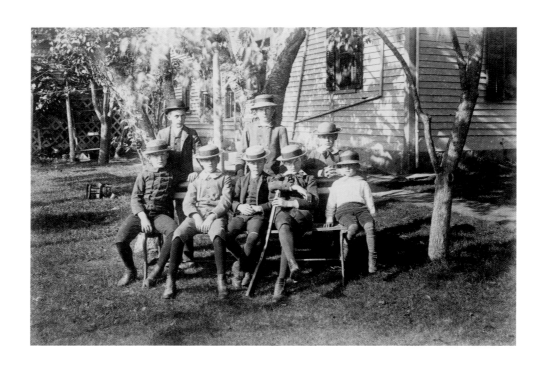

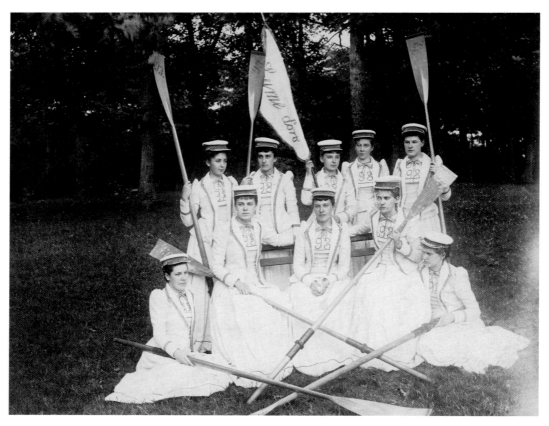

(top) Everett Augustus Scholfield, eight boys on lawn in front of house, Mystic, Connecticut, ca. 1875, photograph, 4 x 5¹⁵⁄₁₆ in. (1980.26.20)

(bottom) Unidentified artist, members of Lume'd'oro, Wellesley College women's rowing club, ca. 1892, albumen print, 8 x 10 in. (1994.99.1)

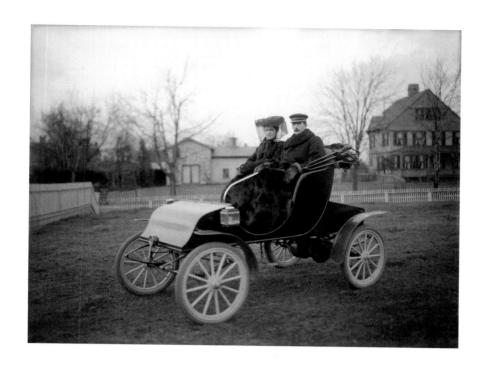

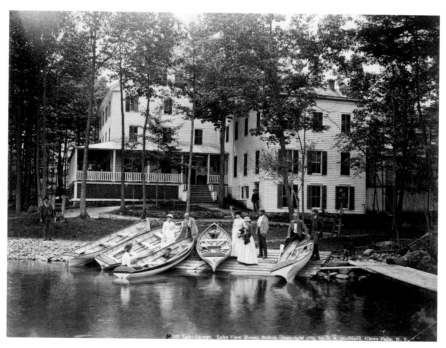

(top) Frederick Kissan Lord, man and woman in early automobile, ca. 1900, gelatin dry plate negative, 6⅝ x 8½ in. (1987.57.657)

(bottom) Seneca Ray Stoddard, *Lake George. Lake View House, Bolton*, 1889, albumen photograph, 6⅜ x 8¼ in. (1985.60.1)

Seneca Ray Stoddard (1843–1917) was trained as a sign-painter but turned to photography in the 1860s. A prolific photographer, artist, writer, poet, cartographer, and lecturer, with a studio in Glens Falls, New York, he traveled throughout the Adirondack region of New York State, recording and selling images featuring the geography and the life of that popular resort area.

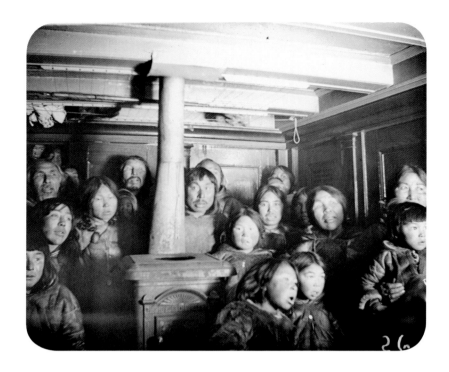

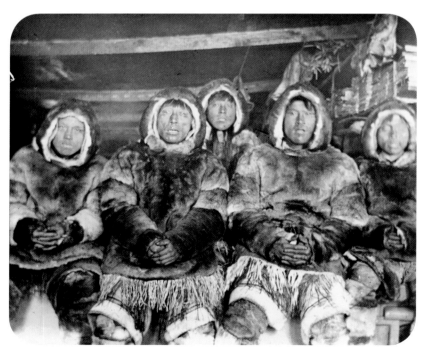

(top) Captain George Comer, Canadian Inuits posing in the cabin of the schooner *Era*, ca.1906, lantern slide prepared by Ferris C. Lockwood from Comer photograph, 3¼ x 4 in. (1966.339.9)

(bottom) Captain George Comer, five Canadian Inuits, ca. 1906, lantern slide prepared by Ferris C. Lockwood from Comer photograph, 3¼ x 4 in. (1966.339.56)

Captain George Comer (1858–1937) was a whaling captain from New London, Connecticut, and New Bedford, Massachusetts, who took up photography to pursue his interests in natural history. Many of his views document the Inuits of Hudson Bay, with whom he often spent the winter during his whaling voyages.

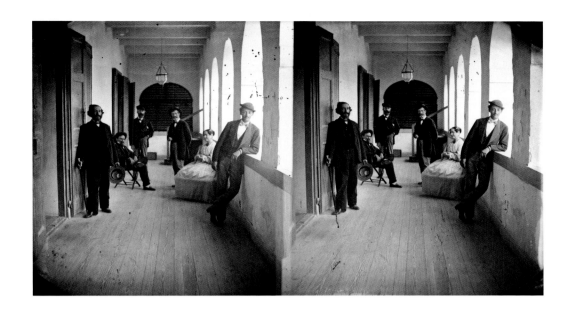

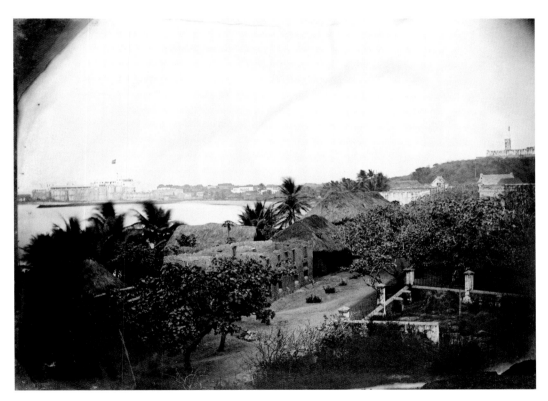

(top) Everett Augustus Scholfield, people on porch, probably at St. Croix, Danish West Indies, 1871 or 1877, collodion glass stereograph negative, 4 x 7 in. (1977.160.2075)

(bottom) Unidentified artist, Dutch fort Elmina Castle, Gold Coast, Africa, ca. 1865, ambrotype, 6½ x 8½ in. (1980.22.3)

An unidentified photographer captured this rare early image of the African coast for John F. Brooks, an American merchant who worked there in the 1860s. Established by the Portuguese in 1482 and captured by the Dutch in 1637, Elmina was an important entrepôt for the trade in African gold and slaves for more than 300 years.

Everett Augustus Scholfield, folding boat, ca. 1875, *carte de visite* albumen photograph,
2⅜ x 3⅝ in. (1976.166.245)

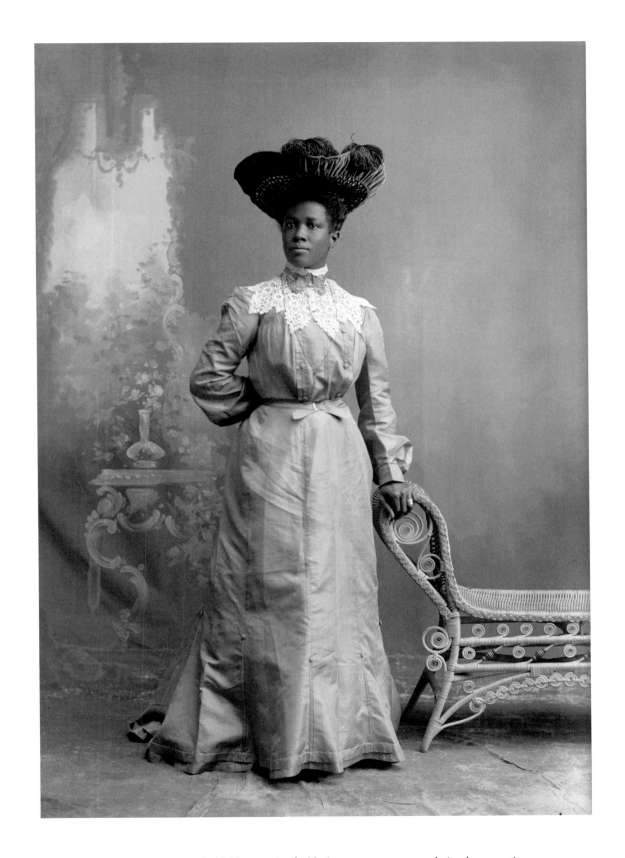

Everett Augustus Scholfield, portrait of a black woman, ca. 1900, gelatin glass negative, 6½ x 4½ in. (1977.160.365)

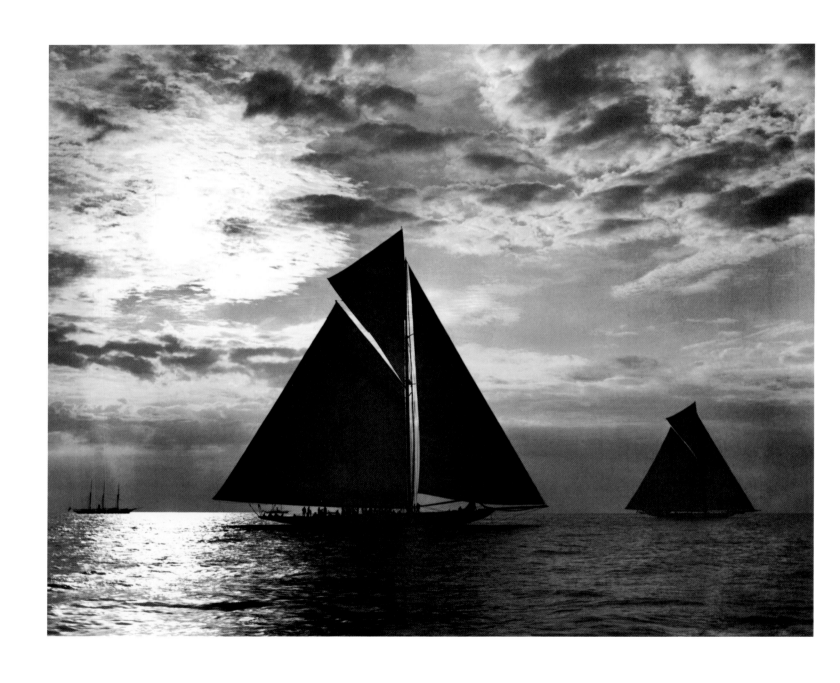

Arthur F. Aldridge, *Constitution and Columbia*, 1901, glass negative, 8 x 10 in. (A.1984.187.39)

Arthur F. Aldridge (1861–1923) came to New York from England at age 22 and worked as a sportswriter, photographer, and editor.

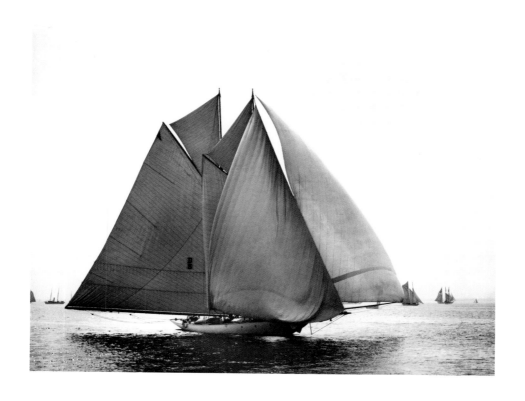

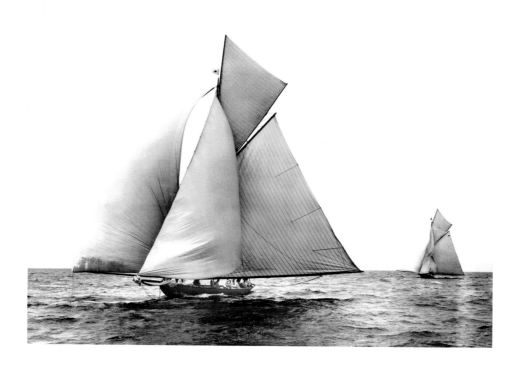

(top) Charles Edwin Bowles, *Elmina*, 1901, glass negative, 8 x 10 in. (Y.1984.187.833)

(bottom) Charles Edwin Bolles, *Canada and Zelma*, 1896, glass negative, 8 x 10 in. (Y.1984.187.387)

Charles Edwin Bolles (1847–1914) was active in New York from 1881 to 1907.

Morris Rosenfeld and Sons, ship yacht *Seven Seas* under sail, 1937, soft negative
7 x 5 in. (1984.187.83002F)

Morris Rosenfeld (1885–1968) and his sons, David (1907–1994), Stanley (1913–2002), and William R. (b. 1921) were members, with others, of a New York firm that combined industrial, real estate, and advertising photography with yacht photography. Active between 1910 and the 1990s, the family produced nearly a million images.

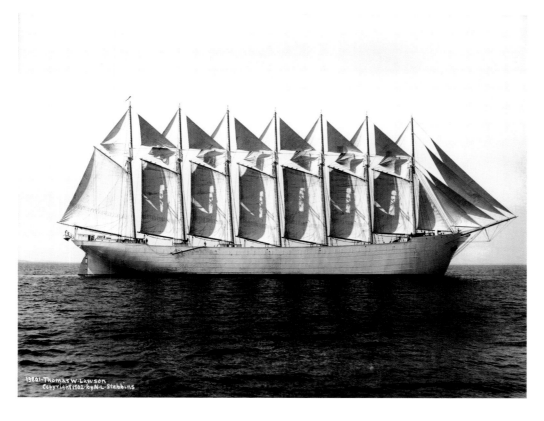

(top) Morris Rosenfeld and Sons, schooner yacht *Hussar*, 1923, glass negative, 6½ x 8½ in (1984.187.4583S)

(bottom) Nathaniel Livermore Stebbins, seven-masted schooner *Thomas W. Lawson*, 1902, gelatin print, 7⅛ x 9¼ in. (1983.23.1)

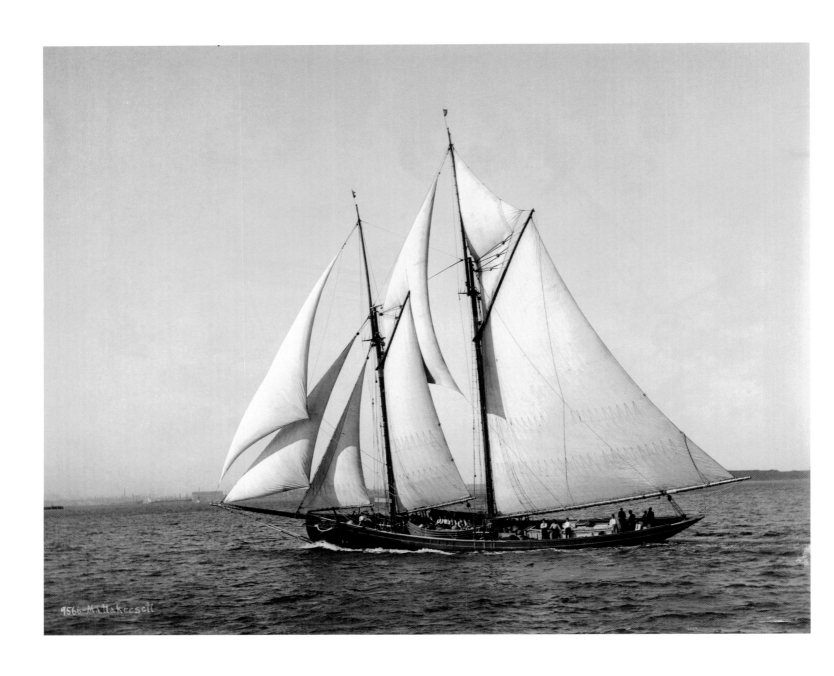

Nathaniel Livermore Stebbins, fishing schooner *Mattakeesett*, 1898, glass negative, 8 x 10 in. (1998.78.41)

A prominent commercial maritime photographer, Nathaniel Livermore Stebbins (1847–1922) was among the first to take his camera onto the water to capture yachts and commercial vessels on large-format glass-plate negatives that preserve remarkable detail.

Morris Rosenfeld and Sons, crew on bowsprit of schooner *Migrant*, 1934, Kodak safety negative, 7 x 5 in.
(1984.187.69953F)

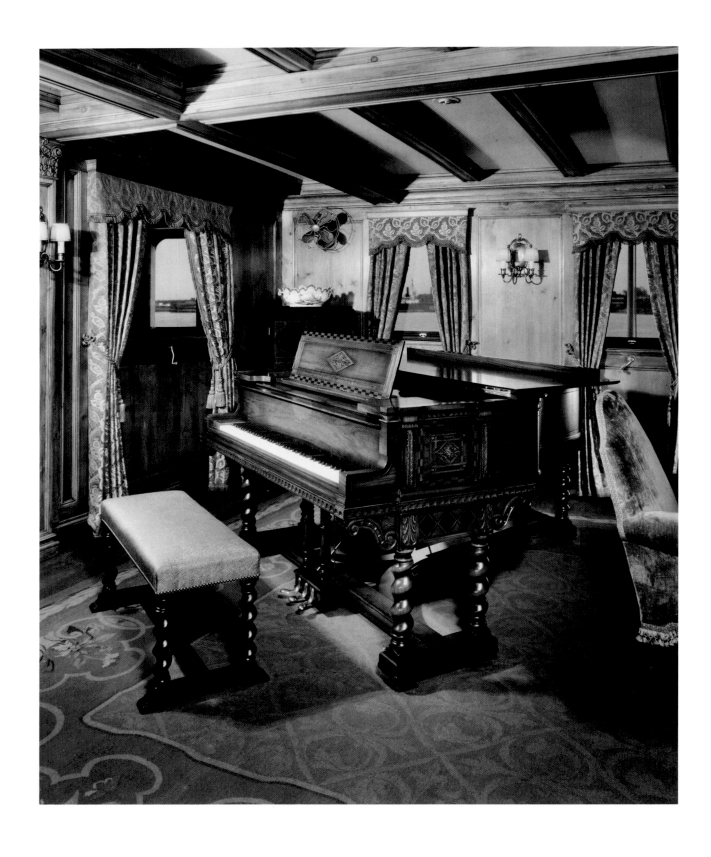

Morris Rosenfeld and Sons, piano in salon of motor yacht *Caroline*, ca. 1931, soft negative,
8 x 10 in. (1984.187.41242)

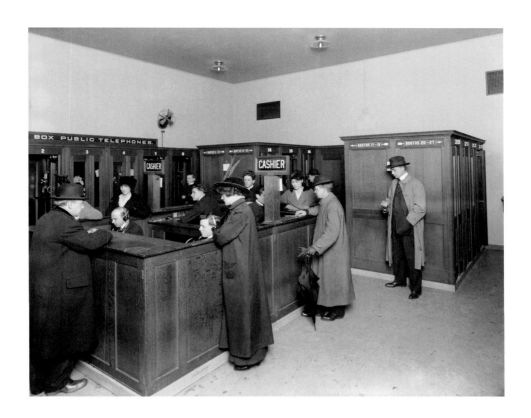

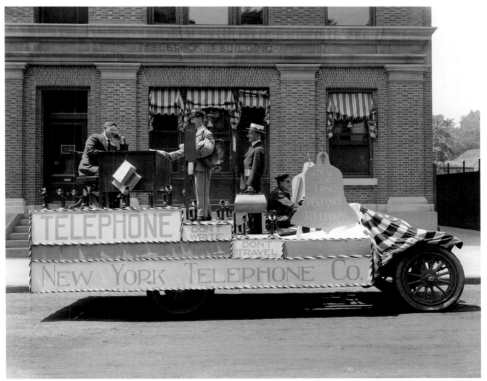

(top) Morris Rosenfeld and Sons, phone booths at Grand Central Terminal, ca. 1915, glass negative, 8 x 10 in. (1984.187.2693)

(bottom) Morris Rosenfeld and Sons, float at Orange parade, ca. 1915, glass negative, 8 x 10 in. (1984.187.3304)

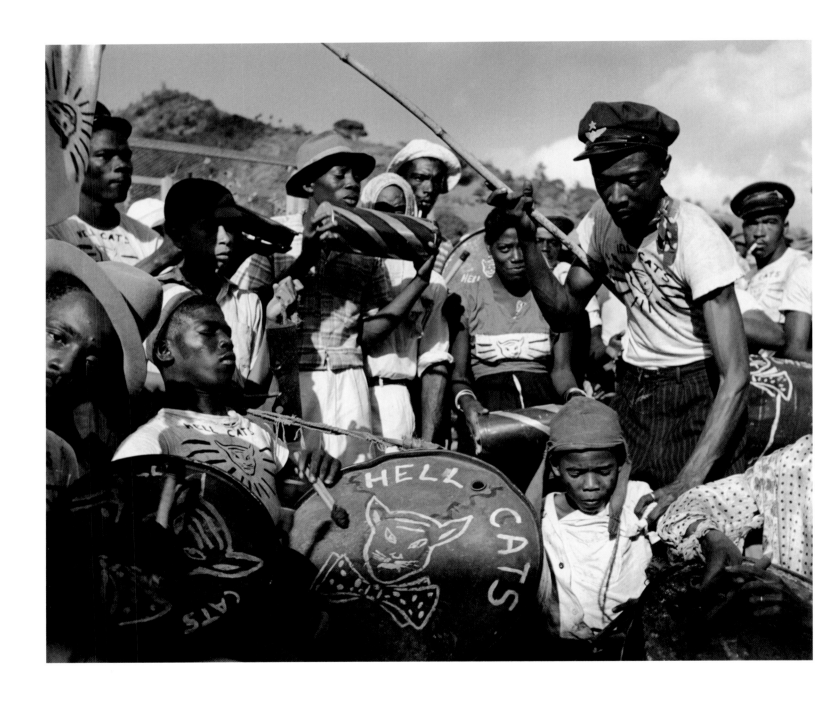

Carleton Mitchell, parade, Grenada, British West Indies, ca. 1946, safety negative, 2¼ x 2¼ in.
(1996.31.949)

Carleton Mitchell (b. 1910) became a photographer in the 1930s to illustrate his magazine articles. His 1949 book, *Passage to Windward*, helped spur Caribbean tourism. A renowned sailor, he wrote many articles for *National Geographic* and *Sports Illustrated* on cruising and racing.

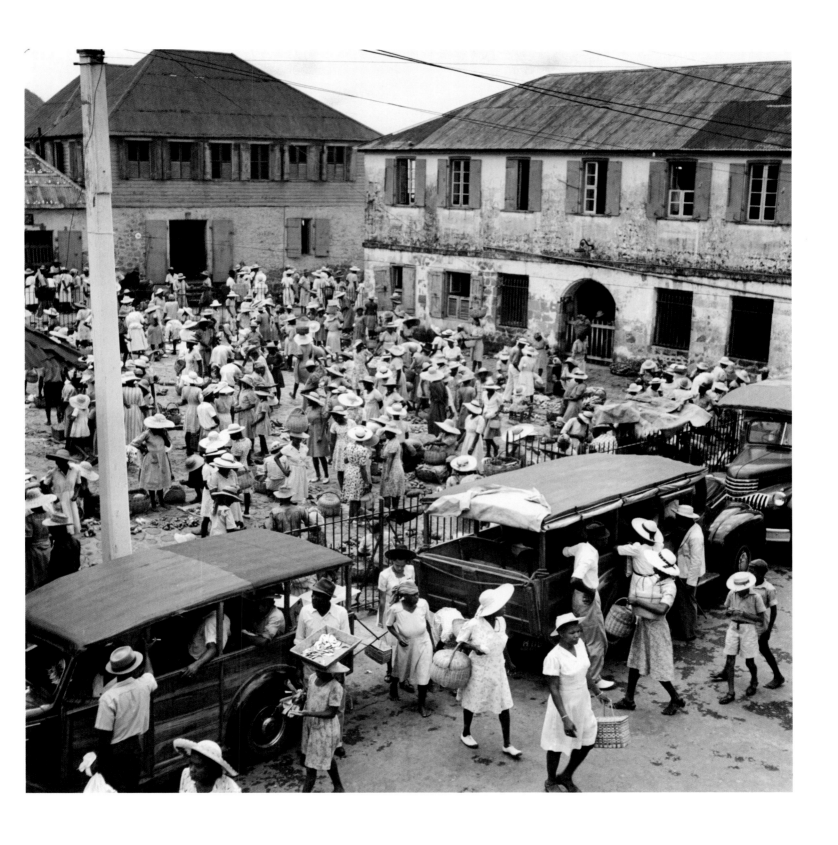

Carleton Mitchell, Roseau, Dominica, British West Indies, 1947, safety negative, 2¼ x 2¼ in.

(1996.31.1580)

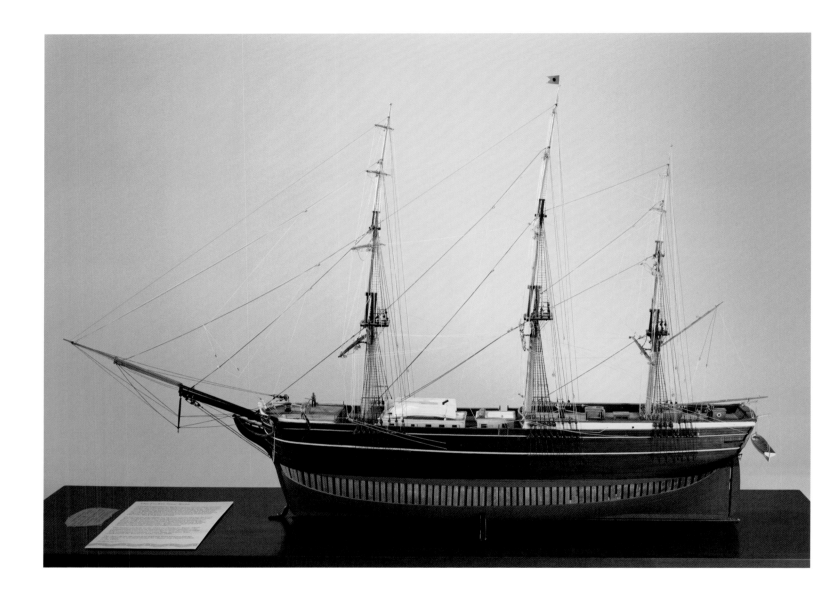

Charles G. Davis, full model of packet ship *Isaac Webb*, ca. 1935, 34 x 53 in. scale 3/16" = 1' (1940.376)

Charles G. Davis (1870–1959) was a sailor, artist, yacht designer, author, and model-builder of great renown. His plans and writings, plus several of his models, are in the collections of Mystic Seaport.

Davis's craftsmanship remains an inspiration to model-builders today and is evident in this model. Davis cut away a section of the model to show the typical triple-deck arrangement common to many large merchant ships employed in the European trades of the 1850s. The 185-foot packet ship *Isaac Webb* was hailed as a model of the shipbuilder's art when she was launched from the busy New York City shipyard of William Webb in 1850. Scheduled transatlantic packet service was an American innovation, introduced by the Black Ball Line in 1817. As part of the Black Ball Line, the *Isaac Webb* made about four scheduled round trips between New York and Liverpool per year from 1850 until the discontinuation of the Black Ball Line in 1879. During the Civil War, the *Isaac Webb* was nearly destroyed by a Confederate commerce raider. However, she had 647 immigrant passengers on board, so she was ransomed rather than burned.

SHIP MODELS

During its early years, Mystic Seaport was unique among American maritime museums in emphasizing the preservation of large historic vessels, not just small boats and ship fragments. Where other museums relied heavily on ship and boat models to present concepts of vessel design and construction, Mystic had whole ships to illustrate these topics. This approach was received enthusiastically by the public and encouraged the founding of more museums with this approach.

On the face of it, this policy might suggest that ship models would be of minor importance to Mystic Seaport's mission, but preserving whole ships had limitations. Costs of maintenance and repairs were high, and only a few historic sailing ships remained as serious candidates for preservation. There was also the problem of having a vessel on display while it was undergoing serious repair work, as this usually called for extensive dismantling. Ship models were to prove a useful aid to visualizing a full-size ship in its complexity of form and intricacy of detail. As the interpretation of the ships became more complex, more focused displays of models proved to be very helpful, and the ship model collection grew in response.

In its early years, the Museum's ship model collection was an eclectic mix of sailor's models and scale models of varying quality by amateur and professional model-makers, lacking uniformity of scale and continuity of theme. This made it difficult to do anything but put them in cases; group them by historic use, geography, or period, however tenuous; and let each model tell its own story. Fortunately, some of the models were outstanding, such as Charles G. Davis's model of the packet ship *Isaac Webb*.

Davis is still widely known among ship modelers, thanks to his four books on model-making, most of which are still in print. A draftsman and yacht designer by trade, he combined seafaring experience, drawing ability, and model-making talent to gain a national reputation in the 1920s and 1930s. His infectious writing style has drawn thousands of enthusiasts to ship modeling for over eight decades, and models are still built from his plans (a fact that displeases historians, as much of Davis's research has been superseded by subsequent findings). His model of the *Isaac Webb* (which was built from accurate sources) stands as a superb example of American craftsmanship in a model of a distinctive vessel type.

Two other outstanding model-makers were gaining recognition in the 1930s and 1940s: Alfred S. Brownell and Carroll Ray Sawyer. Brownell became associated with historian Howard I. Chapelle in the early 1930s and built many models of American merchant vessels and workboats from Chapelle's plans and research. His workmanship was unmatched for neatness and precision. Two models in the Museum's collection—a Bermuda sloop and a motor sailer—illustrate the range of subject matter in Brownell's work.

Carroll Ray Sawyer was primarily (but not exclusively) interested in steel-hulled ships of the late 1800s and early 1900s. Combining a thorough understanding of steel-hull construction with deck machinery and steel spars and rigging, his models of these sailing ships are masterpieces of their kind. Sawyer built two

models of the steel four-masted bark *Kenilworth*, the first of which is now in the Museum's collection; he died in the course of building the second model. The hulls of both models showed the in-and-out "strakes" of shell plating with their graceful sweeps and tapers, something seldom seen in models of this type, even today. The models of Brownell and Sawyer marked high points in American ship modeling in the first half of the 1900s.

Because museums usually acquire ship models on a piecemeal basis—through gifts, bequests, and occasional purchases—their collections will vary greatly in quality of workmanship, accuracy of research, and scale. The last is particularly noticeable in a grouping of models, as it is impossible to visualize the size of each vessel in relation to the others. A model to scale 1/8" = 1' (1/96 actual size) will seem inordinately small alongside another that was built to a scale of 1/4" = 1' (1/48), even though both models are of the same type, or even of the same ship. These leaps of comprehension to transcend disparities of scale are impossible for most of us.

Attempts to build ship model collections to uniform scale are successful only when focused on vessels of specific trades, regions, or periods, the narrower the better. When a collection is too broad or inclusive, the problems of research become too great to assure uniform historic accuracy for all models. Also, the scale used for one vessel type might be unsuitable for another. 1/2" = 1' (1/24) will produce models of small craft in manageable sizes, but using the same scale for a 1,000-foot-long ocean liner would result in a model 42 feet long!

Once a uniform scale has been established for a specific group of models, individual subjects must be researched, then built to uniform standards of detail, accuracy, and finish, if the group is to permit undistracted comparisons. Mystic Seaport has several uniform scale collections, including a series depicting the challengers for, and defenders of, the America's Cup since 1851. Built to scale 1/8" = 1', the models are fairly small, modest in detail, but well made and finished, and convey a vivid impression of the development of hulls and sail plans in yachts built for this competition.

The Thomas M. Hoyne Collection of fishing vessel models was built by me to scale 3/8" = 1' (1/32). It consists of only ten models, but the large scale allowed the inclusion of very fine detail in the hulls, machinery, and rigging as well as in the fishing gear. Built to serve as "posing models" for the marine artist Tom Hoyne, their construction was guided by an unusual approach to detail and finish. Accuracy was of course demanded, and this called for much research. Fine workmanship was expected also, but so was realism, which resulted in giving most of the models a worn and weathered look.

The Hoyne Collection had the added benefit of supplementing the Museum's interpretation of its fishing schooner, *L. A. Dunton*, which was contemporary to several vessels depicted by the models. In its restored state afloat, provisions for visitor safety and accessibility mandated compromises in parts of the *Dunton's* deck arrangement and display of fishing gear. This was not a problem for the models, which could be fitted out to show accurately the congestion of working gear and the occupational hazards it posed to the crew.

For many visitors, the most intriguing ship models are the miniature scale models which have grown in popularity over the past half-century. The miniature ship model tradition can be dated back to the Napoleonic Wars, when prisoners of war made ship models in bone, ivory, baleen, fine hardwoods, and metal in a great range of sizes, but seldom to scale. The largest prisoner-of-war models could exceed four feet in length,

but the smallest might be only three inches long, or even less. The smallest examples—the miniatures—found a niche market and inspired succeeding generations of craftsmen to refine the construction methods and build to higher standards of accuracy. Out of this process of refinement came the miniature model as we know it today.

By the early 1900s, miniature ship modeling was a growing hobby in England, and by the 1930s it had caught the interest of American model-makers. Alexander G. Law became one of the best known miniaturists of this period—and one of the most artistic, as his model of HMS *Beagle* shows (page 96). Although a waterline model, it is not mounted on simulated water, but on a map of the Rio de la Plata, one of the *Beagle's* first important stops on its famous voyage. The map and case serve to frame the model, much like a picture. Law's building methods, accuracy, and detail would be refined by succeeding generations, but he had taken an important step in the presentation of a ship model as a work of art.

Donald McNarry, an Englishman with a large American following, is widely regarded as the first to bring large-scale realism to miniature models, beginning in the 1950s. A photo of a McNarry miniature, such as *Taeping*, can easily fool the viewer into thinking that it is to one of the larger conventional scales. Only a trained eye would see that it is small enough to fit on a man's hand. McNarry's models are usually to scales 1/16" = 1' (1/192) and 1/32" = 1' (1/386), and sometimes 1/50" = 1' (1/600) and 1/64" = 1' (1/772).

Waterline settings are favored, but full-hull models on conventional mounting pedestals are often made. The baseboards and cases are notable for use of exotic hardwoods and fine joinerwork.

Lloyd McCaffery, who is a generation younger than McNarry, has established standards of his own in the miniature ship model field, placing much emphasis on the role of the artist as modelmaker. This is most evident in the lively, purposeful activity of finely sculpted crew figures and the intricate carvings, such as figureheads, trailboards, stern and quarter galleries, and other decorative work. Plank-on-frame hull construction follows contemporary practice as closely as would be found in large-scale models. Sophisticated cutaways and interior detailing reflect an imaginative approach to carefully researched aspects of construction and outfitting seldom seen, even in large-scale models. At Mystic Seaport, a model of the whaling brig *Viola* is an early example of McCaffery's approach, which has since grown in sophistication (page 97).

When a ship model is built with ruthless adherence to standards of accuracy and workmanship, but no attention to the realism and the imperfections inherent in any ship, the results can be cold and artless. The concept of a ship model as a work of art is too often associated with models of a strictly decorative nature, with varying degrees of status depending on the model-maker's ingenuity in the use of materials. Ship models as "folk art" is how these creations are usually regarded.

Some ship models built purely as ornaments can transcend their intended purpose, and the folk art rubric, to become art objects of high order. A superb example is a gold and silver model of the side-wheel steamer *City of New York*, made by John Dean Benton in the 1860s (page 98). Its purpose was to adorn the top of a music box, yet its detail and accurate proportions would qualify it to be classed as a scale model. The finish of polished gold and silver lies purely in the realm of decoration, yet does not obscure the verisimilitudes of form and construction.

If the ship model collection of Mystic Seaport stands out from those of its sister maritime museums, it is in the collection's variety of uses and the sense of purpose behind its growth. If the need for a controlled environment keeps them confined to special galleries, we still see their relationship to the vessels and objects on display in other parts of the Museum. The connection between a model and a ship, or the discovery of details in a model that relate to artifacts seen elsewhere, helps the museum visitor link the experience of seeing a full-size vessel to visualizing another vessel, now lost to history.

ERIK A. R. RONNBERG JR.

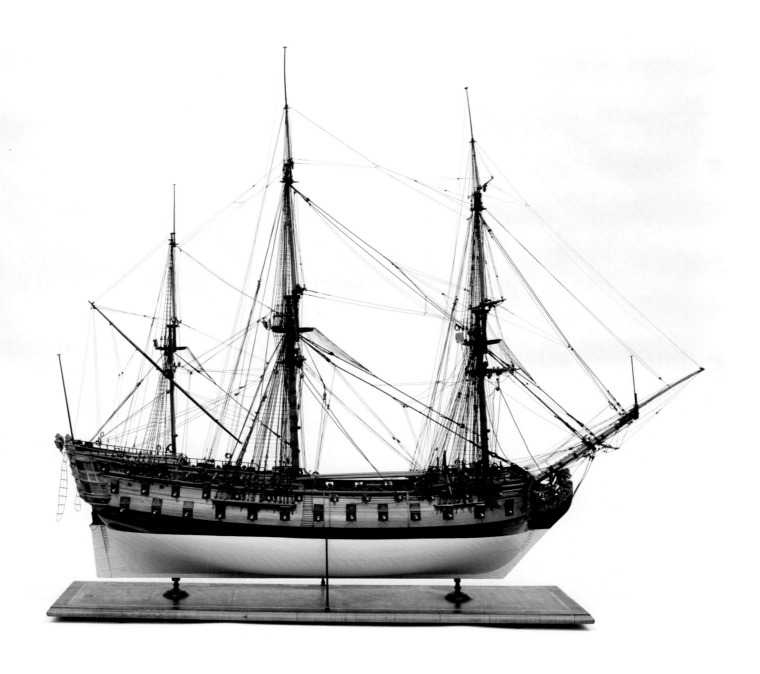

Unidentified artist, HMS *Burford*, ca. 1722, full-rigged model, 55 x 60 x 11 in. (1973.147)

This British admiralty (dockyard) model is a precise plank-on-frame model of the 70-gun ship launched in 1722. Such models are so complete in detail that interior ladderways and cabin bulkheads are included even though they cannot be seen.

Alfred S. Brownell, Bahama catboat, 1947, rigged model (1957.214)

Erik A. R. Ronnberg Jr., fishing schooner *Cavalier*, ca. 1980, full-rigged model, 60½ x 51 in. (1989.100.10)

(top) Alexander G. Law, U.S. frigate *Constitution*, ca. 1938, rigged model, case 7½ x 11¾ in. (1966.315)

In 1932 Alexander G. Law began to build miniature ship models, generally about five inches long. He used human hair for some of the rigging and devised many methods for working at such a small scale. From the 1930s to the 1960s he built a large number of models of famous vessels, placing them on hand-painted maps that related to their service and on a case with a drawer for a book pertaining to the ship.

Intended to depict "Old Ironsides" as she appeared in 1804 during the Barbary War, this miniature model is set on a hand-executed chart of an area of the Mediterranean.

(bottom) Alexander G. Law, HMS *Beagle*, 1958, rigged model, case 7½ x 11¾ in. (1966.319)

Built from detailed drawings and descriptions furnished by the British Admiralty Library and the National Maritime Museum, London, this miniature model of Charles Darwin's ship of discovery is set on a hand-executed chart of the Rio de la Plata off the city of Buenos Aires.

(top) Alexander G. Law, clipper ship *Flying Cloud*, rigged model, 1965, case 7½ x 11¾ in. (1966.324)

This miniature model of Donald McKay's most famous clipper ship, launched in 1851, is set on a chart representing the Hudson River between New York and New Jersey, whence she made her record passages around Cape Horn to San Francisco.

(bottom) Lloyd McCaffery, whaling half-brig *Viola*, 1981, full-rigged cutaway model, 13⅛ x 16 x 8 in., scale 1" = 16'. (1991.180.3.1)

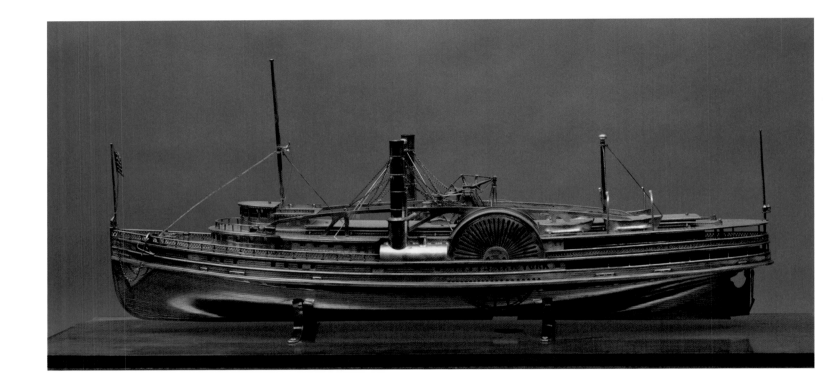

John Dean Benton, side-wheel steamer *City of New York*, ca. 1866, music box model, length overall 25½ in.,
scale approximately 5/64" = 1' (1976.11)

John Dean Benton (1824–1890) was a jeweler in Providence, Rhode Island, and elsewhere who specialized in accurate, highly detailed silver and gold models of ships and locomotives, some, like this one, being mounted on music boxes.

When she was launched in 1861 to provide service between New York and Norwich, Connecticut, the 301-foot *City of New York* was the finest steamboat on Long Island Sound.

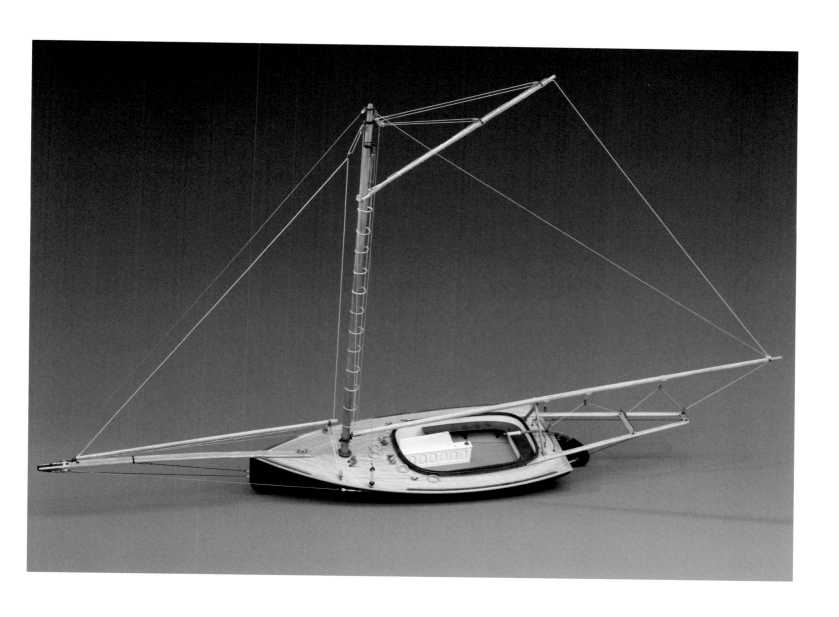

G. R. Bullitt, sandbagger sloop *Annie*, 1997, full-rigged model, 23 x 35 in. (1997.114.1)

22nd Tuesday. Heading SSE. siezed new reef-tackle-blocks
on the main-topsail-yard-arms; In the evening
distributed our last keg of tobacco, abominable stuff—
30 cts ℔ lb. At sunset, shortened sail, heading S by E.
2 AM wore ship. heading NE— overhauled & repaired
the cutting falls & blocks. sent down
the old fore topsail & bent a
new one—

Cutting in

23rd Wednesday. Heading NE by E— pretty good weather—
6h a.m. Mr Perry raised Sperm Whales, about 4 miles
off— 9 a m the Waist-boat got fast to a 40 bbs bull—
went upon him as he was breaching = a few
of the whales brought to for a moment &
Mr Welsh fired a bomb lance into a loose whale
which we chased till noon with no success—
This bull handled his flukes admirably—
Our two boats held off & watched the contest—
and Mr Welsh acquitted himself well— he
avoided his flukes with such good skill— and
at the same time gave the whale such severe
lances— that he soon fired about in his
flurry & then we had to scatter— and
when Mr Whale lay fin up. we saluted
Mr Welsh with 3 hearty cheers— the success
of that battle will be uppermost in his mind
for many a day.

THE G. W. BLUNT WHITE LIBRARY

Amidst the bustle and noise of Mystic Seaport, people hurrying about to see exhibits, docents explaining the customs and crafts of the sea, caulkers, riggers, and shipwrights doing their work in the preserving yard, and the *Sabino* steaming on the river, there is one spot where quiet prevails. Nestled at the north end of the Museum grounds is one of the great libraries of America. The G. W. Blunt White Library is not part of the usual museum tour. Yet, it is the intellectual anchor of Mystic Seaport.

Named for a notable yachtsman and important museum benefactor, whose family can trace its origins back to the very beginnings of the American maritime experience, the library contains more than 75,000 volumes on maritime and related topics spanning the years from the age of European encounter with the Americas to the most recent treatise on modern ship construction. Among the earliest works are such extraordinary items as a complete eighteenth-century edition of J. F. W. DesBarres's *Atlantic Neptune*, an impressive collection of charts in *Portugaliae Monumenta Cartographica*, and several early piloting guides published for mariners. For the modern period the library boasts a collection of more than 9,000 charts, mostly from the 1800s, covering all the oceans of the world.

In addition to publications intended to aid navigators and explorers, the library has an incomparable collection of published memoirs, reminiscences, and journals kept by sea travelers. Some of these are lyrical, others mundane and straightforward. But whatever their literary style, these firsthand narratives reveal the changing nature of life at sea while at the same time reminding us of those elements constant in the life of the seafarer—the endless struggle with nature, the rhythms of work on board ship, relations with shipmates, and encounters with foreign lands.

Indeed, encounter is very much a part of seafaring, and the library is rich in materials left by men and women who ventured far from home to reach new lands to explore, trade, and perhaps settle. Their recollections provide keen insight into the results of these cultural interactions and the ways in which they have shaped the world in which we live.

Printed materials in the library also include more than 800 periodical titles. The library maintains subscriptions to the most important current journals in the field while also holding in its stacks copies of journals now out of print and difficult to find. Researchers make heavy use of the extensive collection of published ship and yacht registers to identify details of vessels as well as their builders and owners. Newspapers devoted to

Robert W. Weir Jr. (1836–1905) came from a family of artists, including his namesake father, a prominent Hudson River School artist and the instructor of drawing at West Point for over 40 years. Young Weir ran away to sea in the 1850s and spent time on several whaleships. This sketch from his illustrated journal on the whaler *Clara Bell* displays some of Weir's inherited artistic talent. During the Civil War he served in the U.S. Navy and contributed pieces to *Harper's Weekly*. After the war, he settled down as a construction engineer in New Jersey. (LOG 164)

shipping as well as government records are also available at the Blunt White Library. Through these specialized sources, we learn which vessels were entering and leaving port and obtain insight about their cargoes, their destinations, and the men who sailed aboard them.

Through the 1800s, America was fascinated with the sea. Ships, sailors, and voyages were a dominant theme in American art, literature, and popular culture. The Blunt White Library's collection of sailing ship cards, such as the example shown opposite, provides dramatic visual evidence of the fascination Americans had for the sea. Printed on heavy card stock these cards circulated widely, advertising ships ready to sail. Promising quick and safe passage the cards celebrated famous captains and their commands. Patriotic themes dominated, extolling America's prowess at sea and the nation's growing economic might.

At the core of the library's collections are more than one million unique manuscript items. No other library in the world has such an extensive and accessible collection of original documents relating to the history of America and the sea. Among these are more than 1,200 ships' logs and journals. Many of these are from the days of whaling, but they also include trading vessels, passenger ships, fishing vessels, and warships. As the official record of a voyage, a logbook chronicles the daily routine and conditions aboard ship. Journals are personal diaries that include the writer's thoughts as well as descriptions of both commonplace moments at sea and extraordinary moments of adventure and danger. A good number are illustrated, providing dramatic visual evidence to supplement the daily narrative. These firsthand accounts tell much about trade patterns, weather and environment, shipboard working and living conditions, race relations, and politics. The authors of these accounts bring us as close to the actual events as we can ever get.

Seafaring was a business vital to the growth of America. Shoreside activities of shipowners and others are chronicled in many of the library's nearly 300 manuscript collections. The personal and business papers of brokers, bankers, shipbuilders, customs officers, tavern keepers, ministers, and others tell us much about maritime enterprise. They also reveal the social history of "sailortowns," those seaport centers where sailors, immigrants, dockworkers, preachers, crimps, and "suspicious people" gathered. The records of seamen's bethels—places of refuge established by reformers where seamen might find a meal, a bed, and a Bible—help document the lives of ordinary seafaring men and women whose stories would otherwise be lost.

Great research libraries must never stop collecting, nor can they ignore changing lifestyles and new technologies. Modern seafarers are less likely to keep diaries or write memoirs and reminiscences. Rather than wait for such items to arrive—which may never happen—the library has established a vigorous program of oral history to capture the lives of contemporary men and women who live by the sea. With the aid of an experienced crew of volunteers, the Blunt White library has recorded, transcribed, and indexed more than 600 interviews and lectures. This incomparable effort is saving the present for the future.

Likewise, Mystic Seaport has pioneered in finding new ways to make its collections available. Traditionally, "available" meant either making a personal visit to the library or perhaps reading printed collections of documents. Since 1997, the Blunt White library has carried its mission of accessibility into the world of digitization. Free and open to all, more than 250,000 images are available for viewing on the World Wide Web,

and each day more than 1,000 people visit the library site. Here they will find important examples of all the types of maritime materials kept by the library. For some the electronic visit will be sufficient, for others, however, it will provide only a tantalizing introduction to the world's greatest collection of American maritime history.

Whether crossing the Bering Sea or facing a wild and furious North Atlantic, for centuries coming to America meant crossing the ocean. Those who settled here saw the sea as a rich pasture from which they could draw their livelihoods. Others viewed the great oceans as moats to protect them from the Old World, and still more used the sea as a highway to trade and barter. America has a rich history with the sea, a history that can be discovered in the stacks and vaults of the G.W. Blunt White Library.

WILLIAM FOWLER

Published in 1670, and based upon the work of the Dutch Arnoldus Montanus, *America: being the latest, and most accurate description of the New World : containing the original of the inhabitants, and the remarkable voyages thither. The conquest of the vast empires of Mexico and Peru, and other large provinces and territories, with the several European plantations in those parts. Also their cities, fortresses, towns, temples, mountains, and rivers. Their habits, customs, manners, and religions. Their plants, beasts, birds, and serpents. With an appendix containing, besides several other considerable additions, a brief survey of what hath been discover'd of the unknown southland and the Arctick region. Collected from most authentick authors, augmented with later observations, and adorn'd with maps and sculptures* was an enormous undertaking by John Ogilby (1600–1676), planned as part of a series describing the entire known world. The engravings, while at times ludicrous, are nonetheless captivating in their lush composition. (Z917035; Z917035.A)

British Royal Navy Captain John Ross (1777–1856) was in command of an attempt to find the Northwest Passage when he drew this whimsical image of an escaping polar bear.

It and an impressionistic sketch of the birth of an iceberg (opposite) are included in Ross's book, *A voyage of discovery: made under the orders of the Admiralty, in His Majesty's ships Isabella and Alexander, for the purpose of exploring Baffin's Bay, and inquiring into the probability of a north-west passage* (1819). Ross's failure to find the Northwest Passage resulted in his disgrace, and it took him years to regain his reputation. (G6501818R.8)

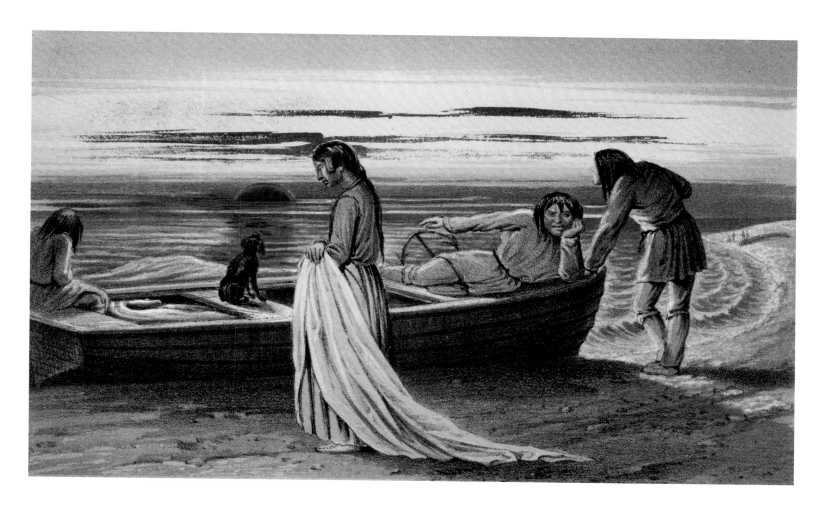

Henry Youle Hind (1823–1908) was an English-born geologist and explorer who in 1861 traversed Labrador and its river systems. His account was published in London in 1863 as *Explorations in the Interior of the Labrador Peninsula: The Country of the Montagnais and Nasquapee Indians*. Along with his artist brother, William George Richardson Hind, Henry encountered situations such as the one depicted here in which a Montagnais Indian man stricken with influenza is being attended to by his wife and family before leaving on a journey to vacate the infected region. In the adjoining image, Hind and his group navigate one of the many rapids amidst the towering cliffs along the Moisie River. The trip down the river included a number of portages and some narrow escapes from disaster.

Royal Navy Lieutenant (later Captain) George Tobin (1768–1838) was a talented watercolorist as well as a prominent naval officer whose associates included Captain William Bligh and Admiral Lord Horatio Nelson. These views of a native "Speightstown boat" at Barbados and the pilot schooner *Hamilton* of Norfolk, Virginia, are among 73 marine watercolors Tobin made in various parts of the world between 1794 and 1818. (VFM965.A; VFM 965.B)

WINTER DRESS OF FARMER, NEAR SYRACUSE

LADY OF SMYRNA

A PERSIAN AT SMYRNA

ARMENIAN PRIEST SMYRNA

Edward C. Young (1806–1856), a U.S. Marine from New Jersey, was serving on the USS *Concord* in the Mediterranean in the early 1830s when he produced this watercolor sketchbook, "Costumes of the Mediterranean." He included the costumes of several nationalities as seen in a number of Mediterranean ports, primarily Smyrna, Turkey, as well as several uniforms of crew aboard the USS *Concord*. John Henry Hill, a foreign missionary and educator serving in Greece, added critical and encouraging comments in the margins of several pages. (VOL 464.A, B, C, D).

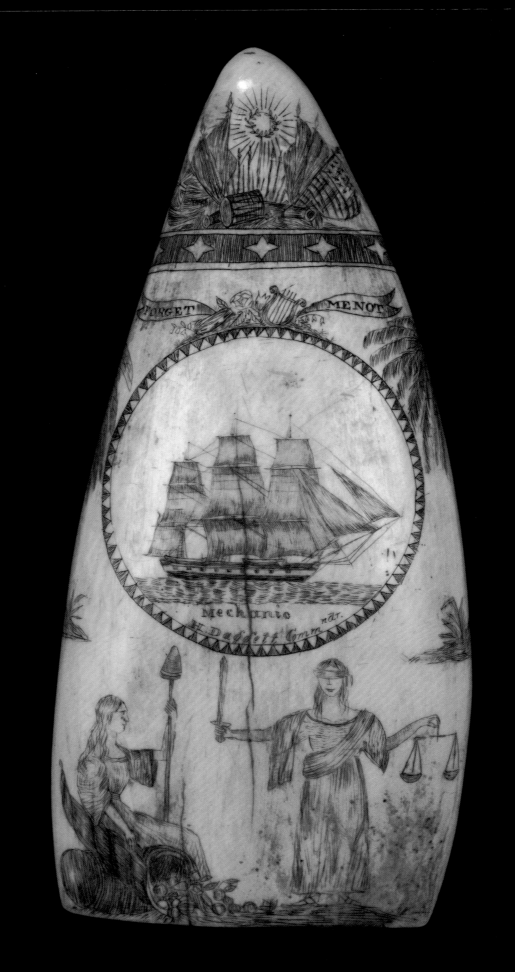

SCRIMSHAW

The waterfront, the cobblestone streets, the architecture of the place and period, the whaleship *Charles W. Morgan*, and the craft exhibits all convey the feel of the business of whaling, while another aspect of Mystic Seaport conveys the heart: the art of scrimshaw.

Mystic Seaport acquired its first scrimshaw piece in 1931, just two years after the institution was founded. This collection of seafaring folk art grew significantly after 1939. As Richard Malley wrote in his book *Graven by the Fishermen Themselves*, the Museum's remarkable scrimshaw collection is a result of "care and connoisseurship" by the dedicated staff.

The scrimshaw produced by some of the 200,000 whalers from New England and New York between 1820 and 1920 is a part of our heritage, but to understand this variant on the art of carving ivory, one needs to know it in the context of life on board a whaling vessel.

In search of sperm whales (which have teeth) for the high-quality oil that could be rendered from their blubber for lighting and industrial lubrication, whalemen wandered the temperate waters of the world. In search of right and bowhead whales (which have baleen rather than teeth) for lower-quality oil and for the baleen that could be manufactured into flexible objects, whalemen ventured around the world and into the Arctic. Life on board their vessels was difficult, fraught with danger, wretched food, horrid living conditions, low pay, often harsh punishments, and unbearable boredom. With the depletion of whales, voyages that might have taken 18 months in the 1820s took 36 months by the 1850s. With so much idle time, scrimshaw, a pastime distinctive to whaling, became an adjunct to the hunt of the leviathan.

Scrimshaw was a popular diversion because it was so time-consuming and demanded such intense concentration. It was an ideal way for inspired whalemen to keep their dexterous hands and clever minds occupied. This mostly masculine art form was also an emotional outlet whose reward was the pleasure of having completed a piece and the joy of using it or giving it to a loved one.

Captains, mates, seamen were all involved in scrimshandering. Whether it was made by greenhands in the dingy forecastle or officers living in private quarters aft, this American folk art reflects the society it came from.

Today, scrimshaw is commonly perceived as carved or engraved sperm whale teeth. Custom and tradition dictated that the ivory teeth should be given to the whalers, for although considered worthless by the industry, they were perfect material for scrimshawing. Only the lower jaw of the sperm whale contained teeth, but because it could take 25 to 50 whales to produce a full cargo of oil, there were plenty of these teeth, averaging in size from four to ten inches in length.

Unidentified artist, whaleship *Mechanic*, ca. 1838, engraved sperm whale tooth, 7⅝ in. (1955.1037)

Patriotic imagery and the plea "FORGET ME NOT" surround a portrait of the Newport, Rhode Island, whaleship *Mechanic*, with the name H. Daggett, who commanded her on her first voyage, 1834–1838.

The shape of the tooth played a role in the design to be used. Whaling, family, patriotism, and home-towns, alone or in combination, might end up on these purely decorative items. Those most valued pieces might contain additional information, such as names of captains and ships, dates, and even the name of the scrimshander.

The jaw of the sperm whale also produced flat pieces of panbone; it, too, provided a good surface on which to engrave. Whaling scenes were among the most popular subjects for both teeth and panbone. A superb example of this from the Museum's collection is seen on an irregularly shaped piece of panbone over a foot in length and half a foot high (page 120, bottom). The whaleship on the right is busy stripping the blubber from the animal and hoisting it on board in preparation for rendering the oil in the tryworks on deck. On the right-hand side of the bone, three whaleboats pursue another whale that is spouting. In the background, a third whale is breaching. The rare use of color, which draws the eye to the whale's red blood as it is "cut in," adds to this fine example of scrimshaw.

The seamen's obvious familiarity with ships and navigation led them to depict vessels that were almost always correctly presented, however crudely. An excellent specimen of vessel portraiture in the collection has the whaleship *Mechanic* engraved in the center of a large tooth, along with the iconic American figures of Plenty with her cornucopia and Justice with her scales (page 112). The captain's name, "H. Dagget Comm ndr," engraved below the ship, suggests this was created on her first voyage from Newport, Rhode Island, in 1834.

Other subject matter seen on these made-to-be-viewed teeth include naval battles, marine life, mermaids and other fanciful creatures, and home life. Human images, be they historic, symbolic, or simply generic, were common scrimshaw subjects. The best images on figural scrimshaw were copied from illustrations in magazines and books. This was accomplished by the transfer or pin-prick method, where an image was placed on the tooth and a sharp instrument pricked through the image onto the tooth, which was then engraved by connecting the dots.

Whalemen rarely saw women on board, except the occasional captain's wife, so it is no surprise that women were depicted on many teeth. *Godey's Lady's Book*, a fashion magazine, was a common source for images of stylish females. The Museum's tooth depicting a woman holding a scarf may well be an example of this (page 121, left). Her outfit is definitely fashionable, as is her coiffure. The very feminine hands would have been difficult to execute freehand. Many other female images in the scrimshaw collection attest to this much-used formula.

But there is much more to scrimshaw than engraved teeth. Carved utilitarian pieces truly reflect the society in which they were made. These humbler objects, made for use on board and at home, are part of a much larger and more varied group than the more famous engraved teeth. Seamen took pride in creating tools for a variety of purposes on their ships. More than two dozen different types of scrimshawed tools have survived.

Scrimshanders had an abundance of time, but few tools. Even symmetrically shaped and rounded pieces were rarely turned on a lathe. Though jackknives were scrimshanders' most useful tools, they also used awls, saws, files, and sail needles. A prominent piece in the Museum's collection is an exception: a scrimshawed lathe (page 117). This implement held the work tightly as it revolved, allowing for hand-turning to shape rounded

sections symmetrically and precisely. Josiah Robinson, probably the ship's carpenter or cooper, constructed this table-sized piece about 1867 on the bark *Cape Horn Pigeon*. Most scrimshaw went unsigned and undated. Indeed, it is a very rare piece that has been identified by both maker and the vessel on which it was made.

Many scrimshanders carved teeth into conical fids for use in splicing rope, but some went further in creating whaleship tools. A particularly apt example is an ivory cooper's croze, a sort of rounded plane used to carve the grooves in the ends of casks to hold the heads in place (page 117). With everything from provisions and water to whale oil being stored on board ship in casks, the cooper and his tools were essential to a whaleship's success. Few coopers have as elegant a croze as this, however.

Ditty boxes held the whalemen's personal items, including their sewing equipment. Frederick and Sallie Smith's box is an exquisite example, with double fingers on the joinings of the oval-shaped panbone and astonishingly intricate inlay work on the compass-rose design of the lid made of bone, wood, ivory, horn, and baleen (page 123). Captain Smith's existing logs, his wife's journals (she made several voyages with him) and an autobiographical description confirm that he scrimshawed, amongst other things, this box between 1875 and 1878.

Pieces made for those at home had a decidedly feminine aspect, combining utility and grace. Each scrimshander applied decoration in his own fashion. There was pierced work, countersinking for inlay, cutouts, add-ons, and engraving, which technically was not engraving but actually incising or scratching. Color, which was hand-rubbed into the incised lines in order to highlight them, might be supplied by red sealing wax, black or blue ink, tar, or soot from the tryworks.

A work basket for sewing or knitting implements could be made from slices of bone interwoven to form a latticework. Women were also presented with scrimshawed thimbles, thimble cases, thread winders, sewing boxes, darning eggs, bodkins, measuring sticks, crochet and rug hooks, knitting needles, tatting shuttles, and swifts. The latter was unquestionably the most difficult scrimshaw object to create. In addition to basic artistry, the carver had to have an exacting sense of mechanics. After the panbone had been sawn and cut, and sliced to make, in the example shown on page 124, some 144 ribs, and slabs had been carved, turned and colored into larger component parts, the intricate assemblage of parts had to open and shut like an umbrella. The result of this intricate work of love was a rotating frame around which the woman at home would wind yarn for knitting.

Scrimshanders also favored an array of kitchen tools. With their appreciation of the fine, hard grain of ivory and the special qualities of the speckled whalebone, perhaps inspired by memories of home-cooked meals, many food-related utensils were formed. Most distinctive is the jagging wheel. Good cooks were a rarity at sea, so thoughts of home-baked pies were ever present. Jagging wheels—also known as crimpers and pie trimmers—held a roller to cut pastry, flute pie edges, and seal pie crusts to prevent overflow. The outer rim of the wheel hub depicted on page 117 leaves no doubt about what was on the carver's mind. It reads in reverse, "Good Pie Well Made." Some jagging wheel frames were carved with tines on one end to prick holes in the crust to release steam. Occasionally, a carver got carried away with his ingenuity. One example in the collection was more symbolic than practical, with carved palmettes on the spoke of the wheel, free-moving ivory balls in the column, and vines and leaves. Beautiful as a piece of sculpture, this fragile wheel would be quite useless in the kitchen (page 122, top, above).

Just as it might be the first piece attempted by a novice whaleman, a corset busk was the first piece of scrimshaw acquired by Mystic Seaport (page 120, top). Thinking of women at home, many scrimshanders turned panbone, or baleen from right or bowhead whales, into the fashion accessory called a busk. This corset stiffener, popular through the 1800s, was placed in a front insert of a woman's corset and worn next to her heart. Nostalgia, love, and sentimentality were common themes for the images and phrases engraved on busks.

Through the first half of the 1800s, a cane conveyed a sense of status for a man ashore. With pieces of panbone and other materials at hand, scrimshanders created elaborate, highly decorated, and impressive walking sticks. Many tops showed variations of the hand pattern, which could symbolize protection, justice, power, and generosity. The Museum has a wide variety of canes with symbolic, figural, and commemorative scrimshawed handles, a selection of which is shown on page 125.

An inspired scrimshander might turn the most utilitarian object into an elegant creation. A carved toothbrush's handle in the collection is enhanced with bandings, and is punctuated with black and white polka dots and delicate turnings, giving a stylish sense of modernity to a period piece (below).

Like most folk art, the 1,590 pieces of scrimshaw at Mystic Seaport emerged from the creative urges of mostly anonymous, untrained individuals. The whalers who passed so much time in their quest for whales in remote places expressed their feelings for loved ones, home, ship, and country by turning the by-products of their industry into decorative and practical items. Viewing their work today brings us as close as we can come to the heart of those engaged in the once-vital, brutal, epic story of American whaling.

MICHAEL McMANUS

Unidentified artist, toothbrush inlaid with baleen and tortoiseshell, n. d., 7 in. (1939.1918)

(top) Josiah Robinson, lathe, ca. 1867, whalebone, metal, and wood, 28¾ in. (1941.288)

Josiah Robinson, of Mattapoisett, Massachusetts, served aboard a number of whaling vessels, including the *Cape Horn Pigeon*, 1869–1872. With this lathe, largely made of whalebone, he was able to turn some of the scrimshaw pieces he produced while at sea.

(above, left) Unidentified artist, cooper's croze, n.d., whalebone and iron, 6⅛ x 2¹⁵/₁₆ in. (1981.64.6)

Though a bit small, this croze would work to head small coopered containers such as buckets and the lantern kegs used for storing emergency provisions in a whaleboat. The semicircular "fence" would ride around the top of the coopered staves while the adjustable post was set so the cutting blade—here an iron spike—would cut a groove into which fit the edge of the container's head.

(above, right) Unidentified artist, jagging wheel, ca. 1850, whale ivory, 6¾ in. (1947.1605)

Though simple in design, this jagging wheel imparts an appropriate message when rolled around a piecrust: "GOOD PIE WELL MADE."

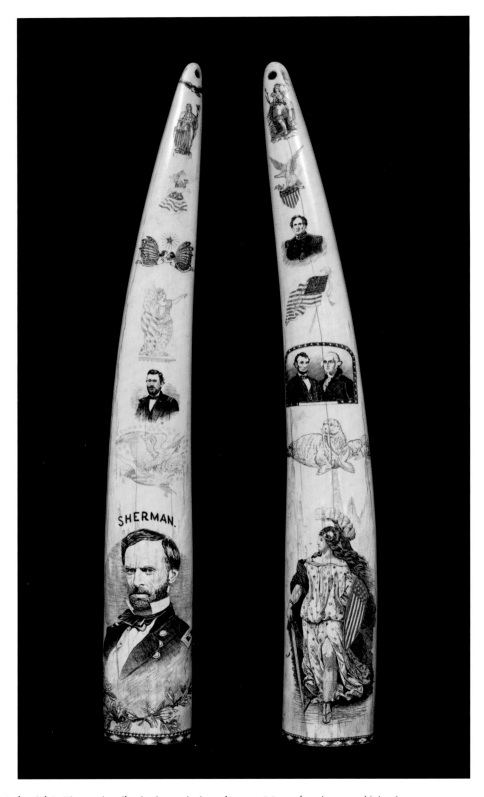

Nathaniel S. Finney (attribution), patriotic tusks, ca. 1865, walrus ivory, 24½ in. (1957.704, 1975.705)

Former whaleman Nathaniel S. Finney (1813–1879) of San Francisco is believed to have carved these two tusks, with Civil War-era images possibly derived from illustrated newspaper engravings. A photograph from the 1880s shows these tusks among the scrimshaw displayed in the Cobweb Palace, a famous sailors' saloon in San Francisco.

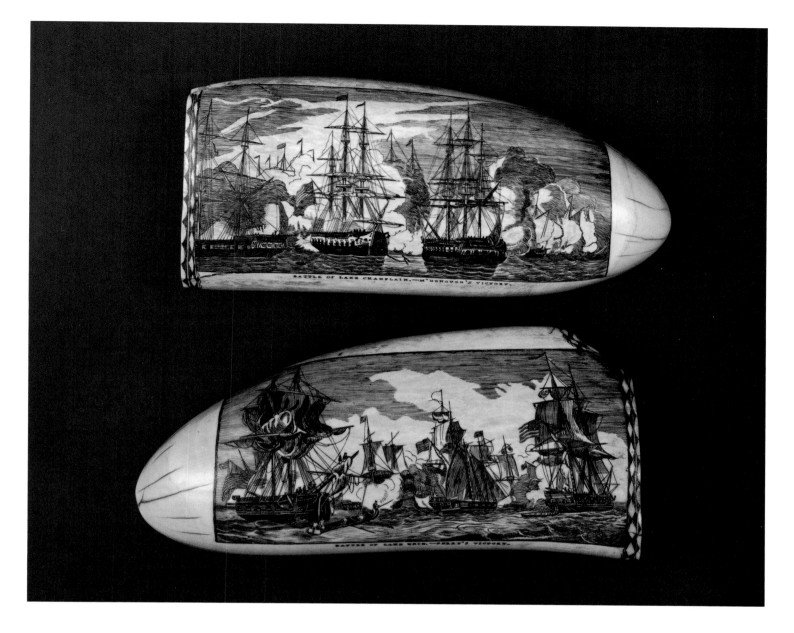

(top) Unidentified artist, *Battle of Lake Erie—Perry's Victory*, ca. 1850, engraved sperm whale tooth, 7½ in. (1941.411)

(bottom) Unidentified artist, *Battle of Lake Champlain—Macdonough's Victory*, ca. 1850, engraved sperm whale tooth, 7½ in. (1941.412)

Captain Francis A. Butts of the New Bedford, Massachusetts, whaleship *Bramin* returned home in 1851 from a three-and-a-half-year voyage, bringing these finely engraved and colored teeth with him. It is not known whether he carved them himself or obtained them from another whaleman.

In September 1813, Master Commandant Oliver Hazard Perry led his fleet of U.S. Navy vessels against a British fleet on Lake Erie near Put-in Bay, Ohio. Fighting under the banner "Don't Give Up the Ship," the American fleet prevailed and retained control of the lake in the struggle for territory in the northwest.

During the War of 1812, when it appeared that the British would invade New York from Canada, a fleet commanded by Thomas Macdonough stopped them during a naval battle at Plattsburgh Bay in September 1814. Soon after, the British agreed to negotiate an end to the war. Macdonough's exploits against the British fleet on Lake Champlain became a source of inspiration and national pride.

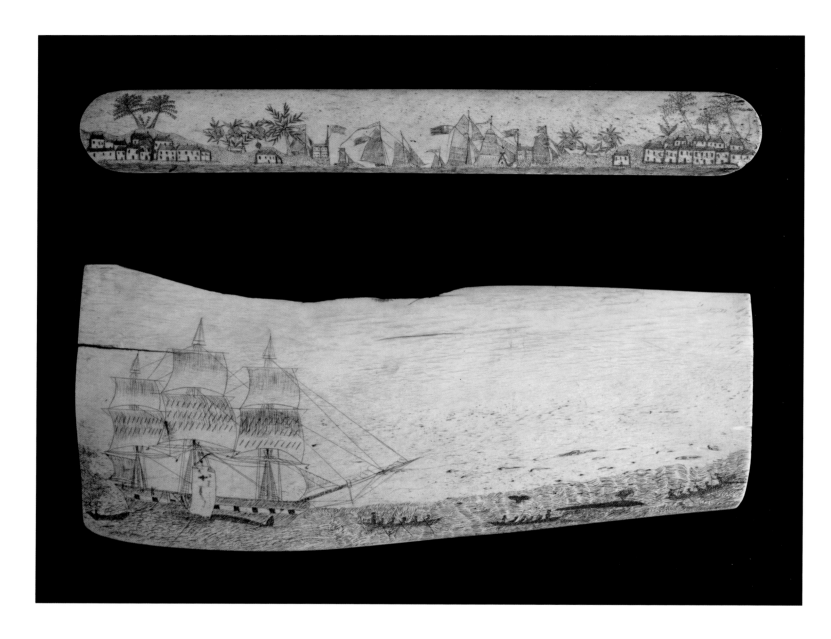

(top) Unidentified artist, corset busk, ca. 1850, panbone, 13⅜ x 1⅝ in. (1959.1134)

This corset busk made of panbone from a sperm whale's jaw contains a heavily inked harbor scene possibly representing the Hawaiian Islands.

(bottom) Unidentified artist, whaling scene, ca. 1850, panbone, 13¼ x 6¾ in. (1939.1962)

This segment of panbone suggests its origins in the lower jaw of a sperm whale. The engraving shows a whaleship "cutting in"—stripping the blubber from a whale to be rendered of its oil—while whaleboats attack other whales at right.

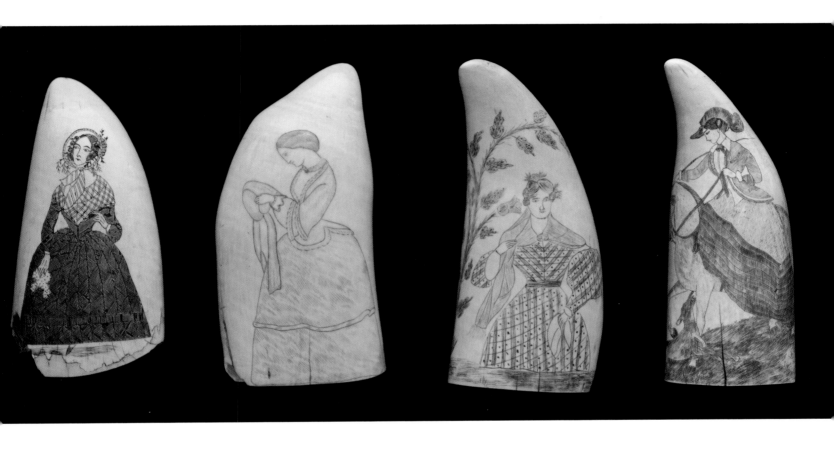

(left to right)

Unidentified artist, portrait of a woman, ca. 1850, engraved sperm whale tooth, 5½ in. (1947.1358)

Unidentified artist, portrait of a woman with a bonnet, ca. 1870, engraved sperm whale tooth,
5⅞ x 3 in. (1947.1351)

Unidentified artist, portrait of a woman, n.d., engraved sperm whale tooth, 6 in. (1939.1769)

Unidentified artist, portrait of a woman on horseback, ca. 1870, engraved sperm whale tooth,
7¾ in. (1993.98.1)

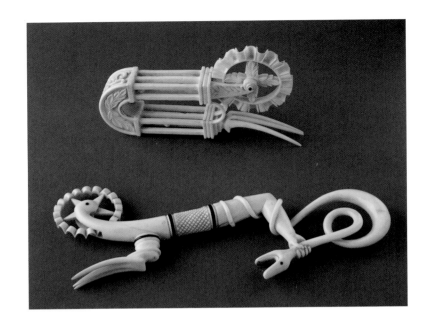

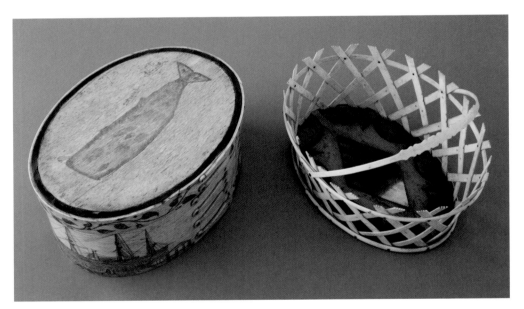

(top, above) Unidentified artist, jagging wheel, ca. 1855, whale ivory, 3⅛ x 5¼ in. (1946.1477)

More decorative than practical, this elaborate U-shaped jagging wheel includes decorated, free-rolling ivory balls in "cages," and a highly carved crimping wheel. It resembles a jagging wheel by Mattapoisett, Massachusetts, whaleman Josiah Robinson but its maker is unidentified.

(top, below) Unidentified artist, jagging wheel, ca. 1855, whale ivory, length 7⅝ in. (1941.440.1)

(above, left) Unidentified artist, oval ditty box, ca. 1850, panbone, 8 x 10 in. (1952.44)

Panbone from the sperm whale's jaw could be planed thin, engraved, steam-bent, and riveted to form a container like this one, decorated with depictions of a merchant ship and a warship. The floral pattern was colored with yellow ink. On the lid, whaleboats attack a sperm whale.

(above, right) Unidentified artist, oval basket, n. d., whalebone, 10 x 8 in. (1939.1769)

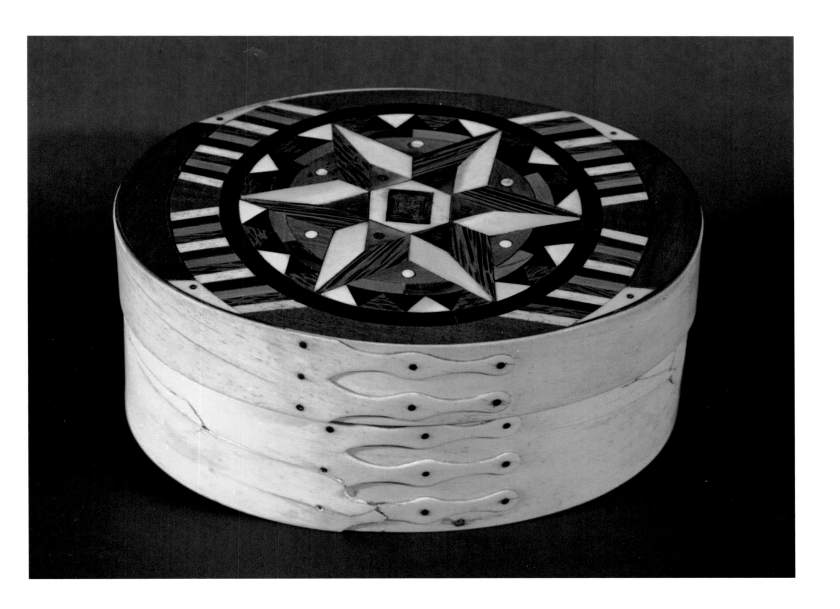

Captain Frederick and Sallie Smith, oval ditty box, 1877, panbone, wood, ivory, baleen, and horn,
6½ x 8⅝ in. (1941.399)

Frederick Howland Smith (1840–1924) rose through the whaling ranks to command a number of vessels, including the *Ohio* and *John P. West*, in the 1870s and 1880s. His wife, Sarah G. "Sallie" Wordell Smith (1840–1896), accompanied him on several voyages and recorded some of his scrimshaw efforts in her journal, now in the collections of Mystic Seaport. She helped him make this panbone ditty box with elaborate inlaid top on board the bark *Ohio* in December 1877.

(above) Unidentified artist, swift, ca. 1870, whale ivory, whalebone, and abalone, 18½ in. (1941.22)

A complicated tool for the simple process of winding yarn from a skein into a ball, the swift was a true labor of love for a whaleman. This remarkable example has 144 separate rib sections, riveted and tied with colored ribbons, with abalone inlay in the base. The cup finial at the top, decorated with a green leaf pattern, was a place to set the ball of yarn.

(opposite) Unidentified artists, canes, ca. 1830–1880, whale ivory, whalebone, baleen, wood, and other materials, 33–36¼ in. (1939.1082; 1939.1828; 1939.1831; 1939.1840; 1939.1857; L.1940.119; 1941.366; 1941.368; 1941.370; 1941.394; 1997.98.1; 1997.98.2)

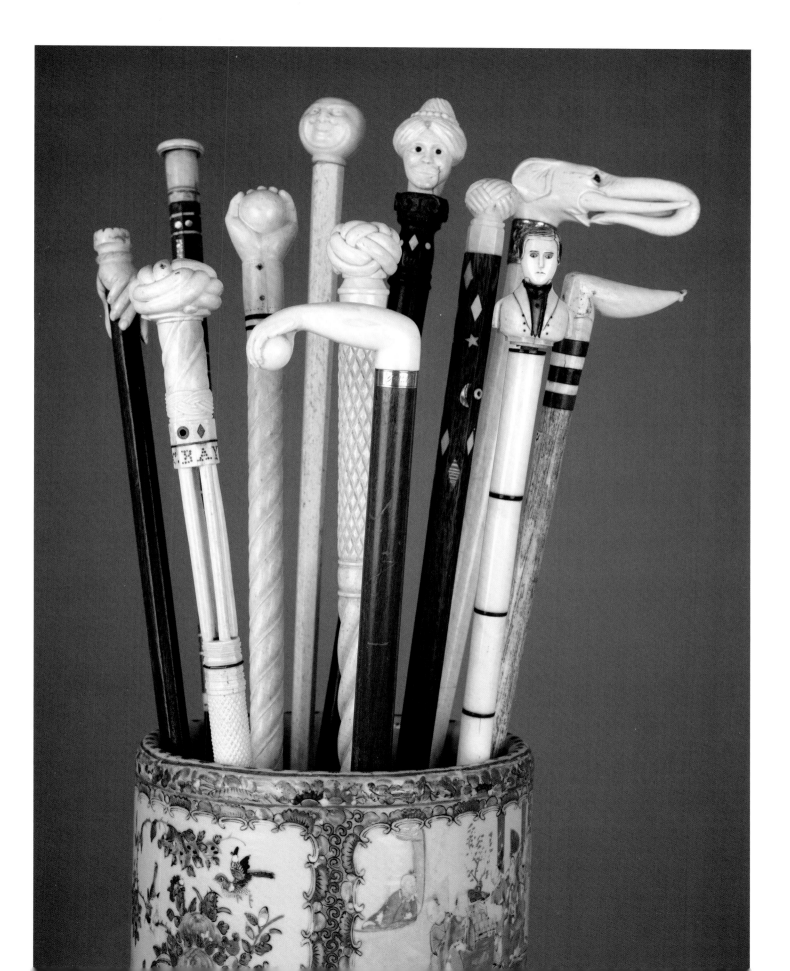

Captain John R. Stivers, box, ca. 1860, abalone, wood, and whale ivory, 10⅛ x 7⅛ in. (1940.108)

Captain John R. Stivers of the New Bedford, Massachusetts, whaleship *Cicero*, made this box with inlays and iridescent abalone shell sheathing.

(left) Unidentified artist, carved and decorated shell, 1882, chambered nautilus shell, 7 in. (1995.117.35)

Captain Timothy M. Benson of the bark *Martha Davis* obtained this highly carved and decorated shell at Manila during his 1882 voyage to Pacific ports, which is detailed in his manuscripts in the Museum's collections.

(right) Unidentified artist, polished and carved shell, 7 in. (1965.415)

This chambered nautilus shell, with its pearly tones, was carved and then etched with acid to add the flower and leaf design. The significance of the etched name TC Forsyth is not known.

DANIEL S. GREGORY
SHIPS PLANS LIBRARY

"The design of a vessel," Cyrus Hamlin writes in *Preliminary Design of Boats and Ships*, "has the purpose of communicating to the builder how the vessel is to be built. Prepared by a naval architect, the design is made up of a collection of drawings, written specifications, and backup material. . . . The most expressive and important of these are the drawings, or plans, prepared by the architect's own hands."

Recently, the innovative and versatile Hamlin donated his design files to Mystic Seaport. There, in the Daniel S. Gregory Ships Plans Library, his work has joined that of many of America's most influential naval architects and yacht designers of the past 150 years.

Taken sheet by sheet, vessel by vessel, or even architect by architect, it may be difficult to grasp the importance of ships plans in the larger context of American maritime history. Does the world need yet another pencil-on-vellum rendering of the accommodations plan of a cabin cruiser, ca. 1962? The cost curves for certain wooden draggers, ca. 1941–44? The ink-on-linen outboard profile of an unnamed coal barge, ca. 1925? For the heirs and assigns of too many naval architects and marine draftsmen down the decades, the answer has been a resounding "No!" A dollop of kerosene and a well-placed match have been their answer to the challenges and responsibilities of historic preservation.

So long as the original vessels themselves survive, one might argue that there is no need to preserve the drawings (or, as the case may be, the carved half-hull models) from which they were built. But it is the rare vessel of any size that survives for more than a few decades. The watercraft preserved at Mystic Seaport (including, of course, the fabled whaleship *Charles W. Morgan* and the unsurpassed collection of small craft) are in many cases the sole extant examples of types and classes of vessels that were once common in American waters. Although contemporaneous artists' sketches or photographs may in certain instances provide useful documentation, nothing can take the place of the actual representations of shape and form—the lines, dimensions, and offsets—from which such vessels were originally built.

From its foundation in 1929, Mystic Seaport and its staff have been dedicated to the collection and

W. Starling Burgess, sail plan of J-Class sloop *Enterprise*, 1930, ink on yellow tracing paper, 20½ x 23½ in. (11.114.4)

W. Starling Burgess (1878–1947), the son of yacht designer Edward Burgess, was an innovative naval architect, airplane and automobile designer, and poet.

The 120-foot (on deck) J-Class sloop *Enterprise* was designed by W. Starling Burgess and built by the Herreshoff Manufacturing Company of Bristol, Rhode Island. In the first America's Cup competition between J-Class yachts, she successfully defended the Cup against the British contender *Shamrock V* in the 1930 series. Her innovative rig design included a flat-topped, triangular boom, called the "Park Avenue" boom for its width, and a duraluminum mast, designed by Charles Paine Burgess, that was one-third lighter than *Shamrock*'s wooden mast.

the Museum struggled merely to catalogue the drawings and provide adequate storage for them. As the Museum's resources and expertise grew, however, and its objectives became more focused, the true significance of the ever-expanding plans collection became clear. Now housed in the state-of-the-art new Collections Research Center and necessarily hidden from casual public viewing, the Ships Plans Library has become one of the glories of Mystic Seaport.

For students of American technology, entrepreneurial activity, and economic and social history, the significance of Mystic Seaport's collection of ships plans is increasingly obvious. The plans are the memory of America's maritime past. Lose them and we lose a critical part of our collective national identity.

For those whose interest in and understanding of ships and the sea are limited, the value of the collection in artistic or graphic terms may take a bit more explaining. It would, for example, be helpful if the Museum could claim among its holdings the plans of arguably the greatest of all traditional naval architects and draftsmen, Frederick af Chapman (1721–1808), the Danish-born son of a British-born Danish naval officer. Author of *Architectura Navalis Mercatoria* (1768) and other superbly illustrated texts, Chapman not only laid the theoretical foundation for the modern science of naval architecture; he created, in drawings of surpassing accuracy and intricacy, a virtual armada of naval and commercial vessels and smaller craft that were the envy of Europe in his day.

Frederick af Chapman's combined mastery of the skills of the draftsman, the engineer, the scientist, and the artist was rare in his day. It is rare in our own. Indeed, as the gifted yacht designer and artist L. Francis Herreshoff (1890–1972) points out in *The Common Sense of Yacht Design* (New York, 1946), many naval architects have had only modest drafting ability and have routinely and extensively employed draftsmen to interpret and give form to their design concepts. The reverse, alas, is also true. From the earliest days of the profession, countless draftsmen (and draftswomen) have toiled over the drawing board to advance the work and reputation of their masters, only to die unsung and unremembered. Sometimes initials suggest the identity of a draftsman; sometimes merely a quirk of lettering or drafting practice; often no clue at all.

The Daniel S. Gregory Ships Plans Library currently houses more than 145 collections of plans, including notable works by Sparkman & Stephens, Philip L. Rhodes, Louis Kromholz, Winthrop Warner, Frederick Geiger, Cyrus Hamlin, and many others. The 17 drawings reproduced here were not selected to represent either the most outstanding or the most typical of the more than 100,000 individual sheets of plans that are now appropriately and securely housed in the collections of the Ships Plans Library. (Other examples can be seen in *Boat Plans at Mystic Seaport* by Anne and Maynard Bray [Mystic, 2000].) Rather, the sampling here displays the range of drafting styles and approaches and suggests the variety of vessel types.

The sail plan of Donald McKay's celebrated extreme clipper ship *Flying Cloud* (1851) is by Charles G. Davis (1870–1959), a marine journalist, painter, and historian, a yacht designer, and a talented draftsman who was also one of the best known and most influential ship-model builders of his generation (page 135). Davis had a genius for reducing the complex and the arcane to the clear and understandable. The rigging of a full-rigged ship held no mysteries for him. It should hold none for those fortunate enough to have access to his drawings or his books.

William Garden, whose delightful clam's-eye view of a 50-foot sloop and drawing of a double-ended ketch are included here (pages 146–147), and whose designs of large and small yachts and fishing and commercial vessels now number close to 1,000, is as adept at carving a half-hull model in the old-fashioned manner as he is at developing a set of lines with pencil on paper. He also possesses the uncanny ability to inject humor and the romance of the sea into even his simplest, most utilitarian drawings and designs. What are the most important attributes of a good designer, I once asked Garden. "Aptitude and patience," he replied. To which I would add, a lifelong love of ships, sailing, and the sea.

The classically trained draftsman and designer Henry Gruber (1899–1959), a German national, worked for several major yacht designers in New York, among them Cox & Stevens and W. Starling Burgess, before returning to Germany in the mid-1930s. He came to prominence at almost the same time as Philip L. Rhodes (1895–1974), with whom he had once worked at Cox & Stevens. There is much to learn from comparing Gruber's Colin Archer–type ketch (page 144) with William Garden's double-ended ketch (pages 146–147) and with the sail plan of the 1926 Rhodes-designed Archer-type cutter—or *redningsskoite* (page 143). That Gruber himself drew the lines of his ketch is proved by the Teutonic redundancy of sections in the body plan. That Garden was his own draftsman is proclaimed by every line and letter on the sheet. And one presumes that Rhodes himself, still a young man in 1926 and not yet the chief executive of his own naval architectural firm, drew *Caribe*'s sail plan with its fanciful decorations. One does not associate fanciful decoration with Rhodes's later work. Yet his skill as a draftsman has never been in question—nor his ability to inject romance into some of his greatest yacht designs.

Another suggestive pairing puts L. Francis Herreshoff's decorative sail plan for a projected Buzzards Bay 14-foot daysailer (page 136) side-by-side with a modern rendering (by former Mystic Seaport resident draftsman Robert Allyn) of the sail plan for an 1870s New Bedford whaleboat (page 137). Here are two small craft, both with strong Buzzards Bay connections and not dissimilar rigs. Yet the characteristic elegance of Herreshoff's enwreathed calligraphy contrasts strongly with Allyn's more unadorned draftsmanship. A gentleman's daysailer and a vehicle for killing whales sail in two different realms and conform to differing graphic standards. The draftsman knows not to confuse those realms.

The sail plan of the Cox & Stevens–designed bark yacht *Sea Cloud* (1931) (page 138) bears comparison both with a John Wells motor yacht and with Charles G. Davis's rendering of the sail plan of *Flying Cloud*. Of all sailing yachts ever built, *Sea Cloud* is the most magnificent. She is a virtual cathedral of a vessel; and, amazingly, she is still in active commission, having defied the forces of political, technological, and economic revolution that should have doomed her on her launching day some 75 years ago. The active career of that earlier sailing cathedral, *Flying Cloud*, was just 23 years. And the Cox & Stevens lumber carrier? Except for these plans, her history is unknown and, it appears, unknowable.

In commissioning the design of *Sea Cloud*, her original owner demanded excess in every respect, beginning with a sky-scraping square rig. This her designer gave her, as the sail plan attests. It may ultimately have been her anachronistic rig that saved her from the wrecker's torch.

As for the Wells-designed motor yacht (page 142), which derived from the same Anglo-Scottish design

tradition as did *Sea Cloud*, complete with a long counter stern and clipper bow, she seems never to have been built. Indeed, John Wells may never have settled on the final configuration of her large (and largely nonfunctional) single stack. Wells's erasures remind us that the designer's work is not finished until a vessel is actually built and has passed her builder's trials.

So, in a different way, does the sail and rigging plan of the 1930 America's Cup defender sloop *Enterprise*, beautifully drawn by Henry Gruber during his time as a design associate of W. Starling Burgess (page 128). The drawing is complex, highly detailed, and impressive, as one would expect with a J-boat. But it was not the plan's final iteration. Harold Vanderbilt, in his book *Enterprise* (New York, 1931), describes the constant alterations that were made to the big sloop's rig and sail plan during her first and last summer of competition. The design of an open-class racer is seldom final until the designer has exhausted all his options to make or keep the boat a winner.

And a further pairing: the outboard profile of the Albert Condon–designed eastern-rig trawler *Roann* (page 141) and the preliminary-lines plan and construction sections for a 30-foot Eldridge-McInnis–designed U.S. Coast Guard rescue boat (page 140). Albert Condon (1887–1963) and Walter McInnis (1893–1985) were virtual contemporaries and, inevitably, professional rivals. Each had been well schooled in marine drafting and had abundant practical knowledge of the arts of the shipbuilder. Each had designed successful yachts (mostly power) but was perhaps better known for designing first-rate fishing vessels and workboats and vessels for government service. Each took pride in his draftsmanship and in producing plans that even an inexperienced loftsman or builder could follow without difficulty.

For their intended purposes, it is difficult to see how the McInnis design for a 30-foot Coast Guard rescue boat and the Condon design for the long-lived dragger *Roann* (now happily in the permanent collection at Mystic Seaport) could be improved upon. And studying the outboard profile of *Roann* and the lines and construction section for the 30-footer, one wonders how a draftsman could more practically or unpretentiously delineate the formal elements of a ship's plan.

David Dillion, who drew the body plan, outboard profile, and general arrangement plan for a little Danish *bindalsbåt* is a devoted student of the world's working watercraft. His treatment of the double-ended *bindalsbåt* demonstrates just how versatile and expressive a pen and pencil can be in skilled hands. Although bolder inking would strengthen the image and make for easier reproduction, the drawing would lose the wonderful delicacy of line and tone that makes the plan so very pleasing to the eye.

Three final comparisons: the complex rendering (ink on linen with color) of a 6-foot, 4-inch barge propeller by one C.R.S., a draftsman with Cox & Stevens (page 139); and two companion sheets of drawings, ink on linen, of interior details prepared by an unknown draftsman with the New York design firm of Henry J. Gielow for Horace E. Dodge's 250-foot steam yacht *Delphine* (1921) (pages 148–49). From the possibly bogus Dodge coat of arms to the pipe organ invisibly lurking behind its ornate carved screen, everything about *Delphine*, including the plans, proclaimed new money—and lots of it. Excess aside, as with the designers of *Sea Cloud*, *Delphine*'s designers did their work well. Today, *Delphine* is back in full commission as a yacht, this time under European ownership.

Has the Cox & Stevens barge propeller survived? After 85 years, not likely. But the continuing existence of this beautifully wrought plan may itself be miracle enough. What computer-assisted design software might allow a modern naval architect to achieve in minutes must have taken the unnamed Cox & Stevens draftsman many hours or even days to create. More than aptitude and patience is involved in work of this high order. Every turn of that big propeller was a hymn to the draftsman's skill and art.

We conclude with a lines plan of a yacht that has for more than a century and a half epitomized the ambitions and achievements of the United States as a maritime nation: the schooner yacht *America* (page 134). Built in New York in 1851 to lines taken from a wooden half-hull model carved by George Steers that evidently has not survived, *America* was from her first great victory in English waters a source of consuming interest to contemporary naval architects and students of yacht design.

In his book *The Low Black Schooner* (Mystic, 1986), John Rousmaniere notes that the first published lines plan of *America* appeared in 1852; that a more detailed lines plan was drawn by Nelson Spratt, an associate of Steers, also very early in that decade; and that William Loring, an English admiral, ordered a set of lines to be taken off and drawn by an Admiralty draftsman when *America* was in dry dock in Portsmouth, England, in late August 1851.

The lines plan reproduced here was drawn in 1859 by E. L. Hopkins under the direction of Henry Pitcher, *America*'s then owner, at whose shipyard on the Thames she was being rebuilt. The plan, which is partially executed in red ink, includes measurements and construction details not available elsewhere.

The plan is a persuasive reminder that traditionally built wooden vessels tend to evolve over time—not merely in rig or sail plan, but sometimes, subtly or otherwise, in hull form and dimension as well. It is the mission of the Daniel S. Gregory Ships Plans Library at Mystic Seaport to understand this evolution, to record it, and, as necessary, to constrain time and tide from turning evolution to dissolution.

LLEWELLYN HOWLAND III

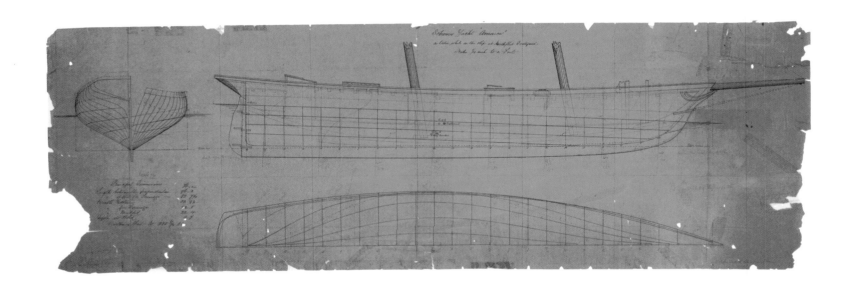

E. L. Hopkins, lines of schooner yacht *America*, 1859, ink and pencil on yellow tracing paper,
39 x 13 in. (1.190.1)

Designed by George Steers and built by William H. Brown at New York, in 1851, the 108-foot schooner yacht
America crossed the Atlantic to represent the U.S. at the 1851 London Exposition and the New York Yacht
Club in a regatta with the Royal Yacht Squadron. When the *America* defeated the entire Royal Yacht
Squadron, winning the 100-guinea cup trophy, the America's Cup competition was born. Very shortly after
winning the cup, the *America* was sold to an English owner. Her original plans have not survived, but this plan
was drawn in 1859 when the schooner was being rebuilt at Henry Pitcher's yard in Northfleet on the Thames.

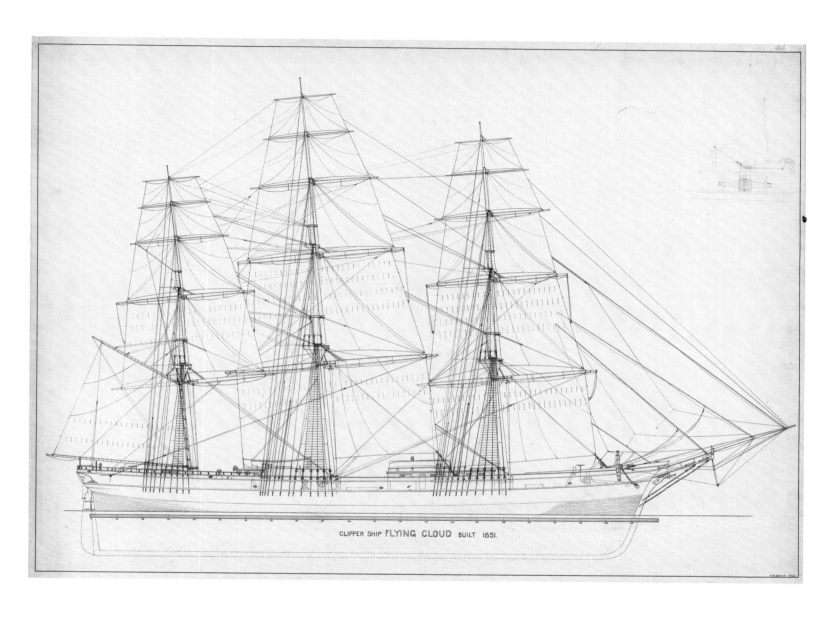

CLIPPER SHIP FLYING CLOUD BUILT 1851.

Charles G. Davis, sail plan of clipper ship *Flying Cloud*, 1922, ink on heavy white paper, 28 x 20¾ in. (uncatalogued)

Represented elsewhere in this volume for his model-making skill, Charles G. Davis (1870–1959) was also an experienced naval architect who had gone to sea in a square-rigged ship, which gave him an intimate understanding of a plan like this.

Launched at East Boston by Donald McKay in 1851, the 225-foot *Flying Cloud* was the fastest clipper ship ever built. In 1851 and 1854 she made two record-breaking runs on the route around Cape Horn between New York and San Francisco, both only 89 days. In light of her grace and her prowess, she remains a popular subject for ship model-builders today, just as she was to Charles G. Davis more than 80 years ago.

L. Francis Herreshoff, sail plan of *Buzzards Bay 14*, 1945, ink on tracing cloth, 27 x 23 in. (38.20.5)

L. Francis Herreshoff (1890–1972), son of Nathanael G. Herreshoff, inherited his father's innovative approach to boat design and construction and became a notable naval architect in his own right, working for W. Starling Burgess before becoming an independent designer in 1925. He is known for many important designs as well as for his opinionated articles and books on design and boat-handling.

L. Francis Herreshoff created this design for Llewellyn Howland, who wanted a larger version of the old Nathanael G. Herreshoff 12½ for sailing on Buzzards Bay. The decorative seaweed design around the title information is a common element on Herreshoff's plans, though that kind of whimsy is seen infrequently in the work of other designers.

Robert C. Allyn, sail plan of whaleboat built by Charles D. Beetle, New Bedford,
Massachusetts, 1974, ink on mylar, 30 x 23½ in. (18.82)

After retiring from his career as a naval architect at the Electric Boat shipyard in Groton, Connecticut, Robert Allyn became the naval architect at Mystic Seaport, measuring and drawing plans of the Museum's vessels and other pertinent watercraft.

Although this 28½-foot whaleboat was never used, it is typical of boats used in the sperm whale fishery and is similar to boats on the *Charles W. Morgan* at Mystic Seaport. The last boat built by the preeminent whaleboat builder, Charles D. Beetle, this boat was commissioned in 1933 for display at the Mariners' Museum in Newport News, Virginia. Mystic Seaport staff members measured the boat in the 1970s, and Robert C. Allyn created the drawings.

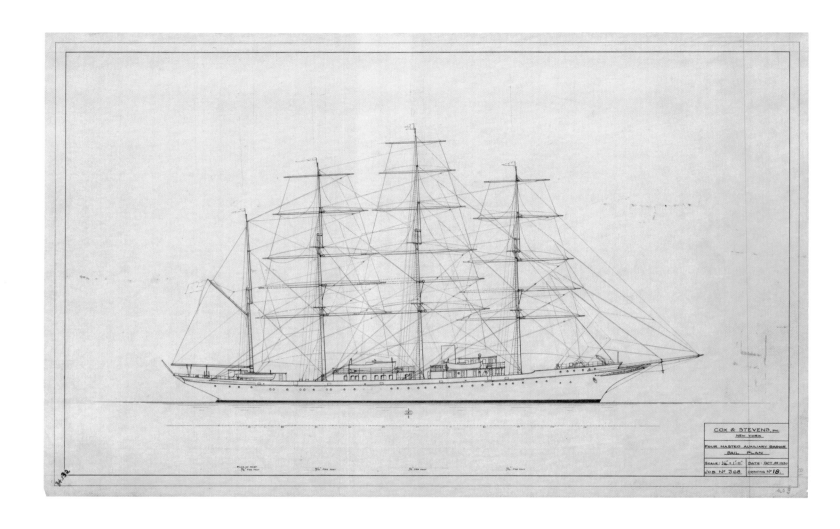

Cox & Stevens, Inc., sail plan of bark-rigged yacht *Sea Cloud*, 1931, ink on tracing cloth, 32 x 20 in. (34.132)

Originally named *Hussar*, this 316-foot auxiliary four-masted bark was ordered from the Krupp Germania-werft of Kiel, Germany, by financier E.F. Hutton for his new wife, Marjorie Meriwether Post. During World War II, the vessel served in the U.S. Navy as a weather ship and sub chaser. She was returned to her owner in 1944, then sold to Dominican General Rafael Trujillo and renamed *Patria* in 1955. After Trujillo's assassination, she passed through a number of hands until 1979, when she was thoroughly and expensively updated, and reentered passenger service as *Sea Cloud*.

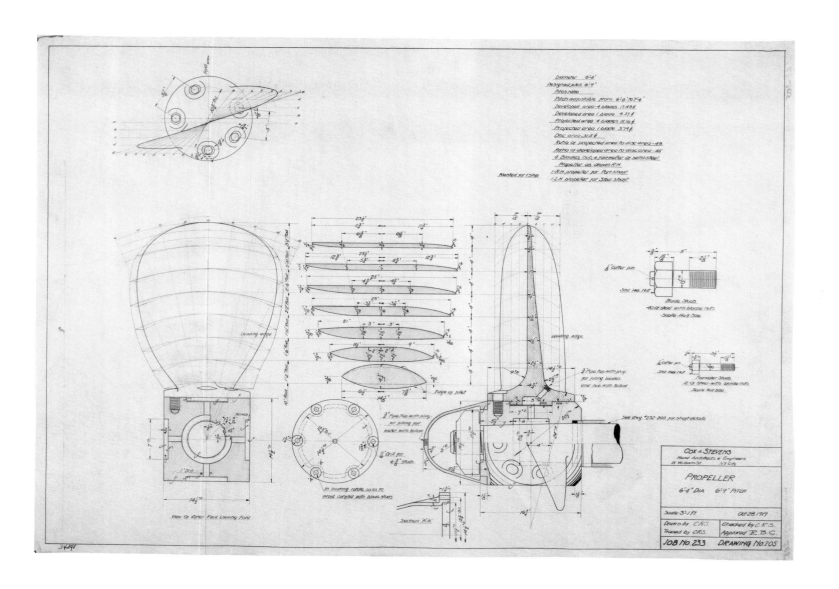

Cox & Stevens, Inc., propeller of twin-screw cargo barge, 1920, ink on tracing cloth, 32 x 22½ in. (34.141)

The four 280-foot barges built to these plans by the St. Louis Boat & Engine Company carried coal from the upper reaches of the Warrior River to Mobile, Alabama, and carried general cargo on the return trip. The *Tuscaloosa* and *Birmingham* were built in 1920, but the names of the other two barges are not known.

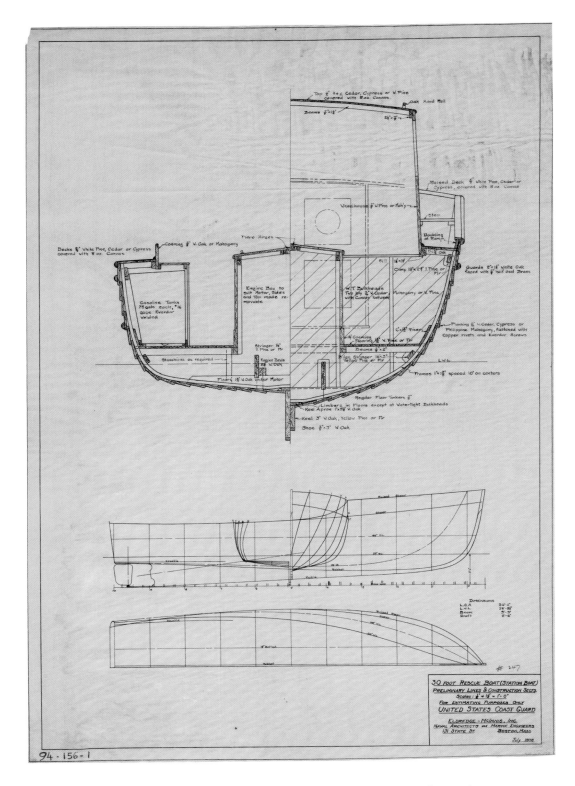

Eldredge-McInnis, Inc., lines and construction section of U.S. Coast Guard rescue boat, 1938, ink on tracing cloth, 21 x 30 in. (94.156.1)

The Boston design firm of Eldredge-McInnis, established in the 1920s, specialized in government and commercial designs, especially fishing vessels.

This 30-foot Coast Guard rescue boat was built by the Gibbs Gas Engine Company of Jacksonville, Florida, in 1938. Other details are unknown.

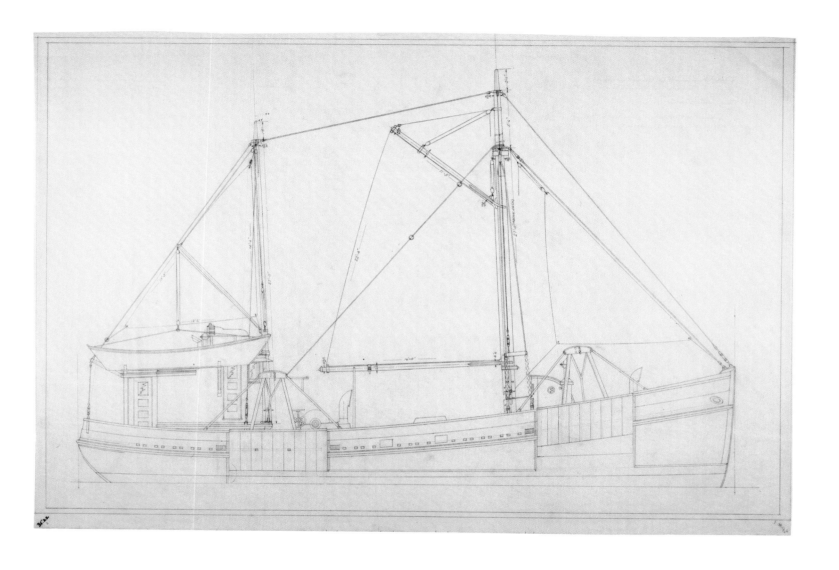

Albert Condon, outboard profile of Eastern-rig fishing dragger *Roann*, 1944,
pencil on tracing paper, 34½ x 24 in. (35.22)

Albert Condon (1887–1963) of Thomaston, Maine, was associated with a number of northeast boatyards, especially Pierce & Kilburn of Fairhaven, Massachusetts. He had an ongoing relationship with Newbert & Wallace of Thomaston, who built many of his fishing vessel designs.

The 60-foot Eastern-rig dragger *Roann* was designed in 1944 and built three years later by Newbert & Wallace at Thomaston, Maine, for Roy W. Campbell, who fished her from Vineyard Haven, Massachusetts. Her second owner, Chet Westcott, brought her to Point Judith, Rhode Island, and her third owner, Tom Williams, sold her to Mystic Seaport in 1997 after many years of commercial fishing. The *Roann*'s original plans, which were donated to the Museum in 1980 with the rest of Condon's collection, were consulted during the major restoration of the vessel that began in spring 2005.

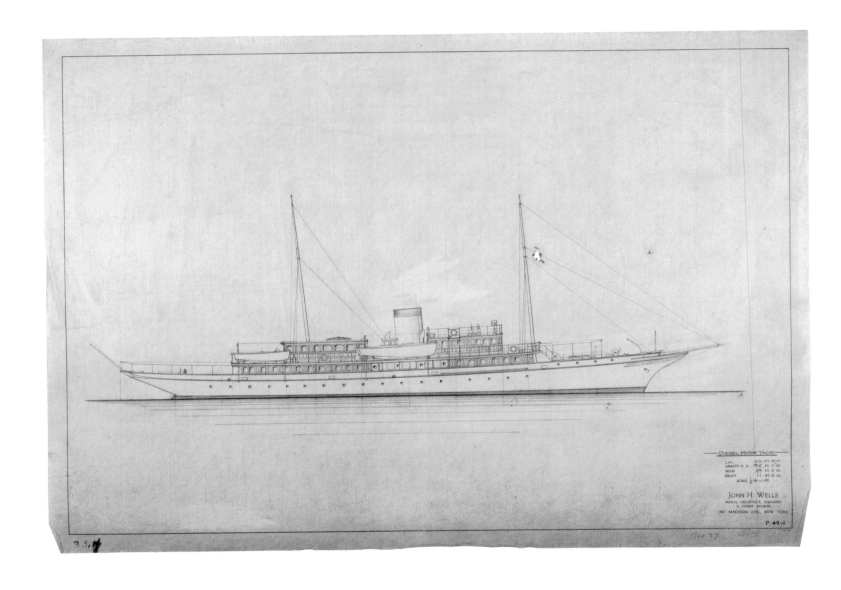

John H. Wells, Inc., outboard profile of motor yacht, 1927, ink on tracing cloth, 34 x 24 in. (33.4)

John H. Wells (1879–1962) graduated from Cornell in 1903 and worked for a number of boatbuilders and designers as well as operated his own naval architecture and consulting firm in New York.

Wells designed this grand 192-foot motor yacht in 1927, but we do not know if a vessel was built to the plans.

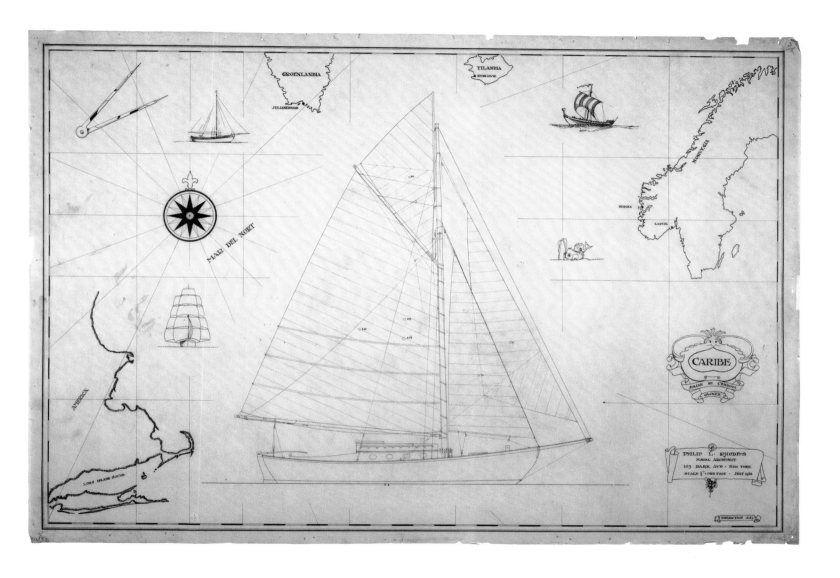

Philip L. Rhodes, sail plan of double-ended cutter yacht *Caribe*, 1926, ink on yellow tracing paper,
36 x 25 in. (80.52.1)

Philip L. Rhodes (1895–1974) is known for a variety of popular sailboat designs. He worked for Cox & Stevens
and took over the firm in 1946.

Rhodes designed this 26-foot version of a Colin Archer *redningsskoite* for Julian Cendoya. Archer devel-
oped the *redningsskoite* especially for the Norwegian government lifesaving service. As a sturdy seagoing craft
that had to tolerate severe weather conditions, it had a high degree of buoyancy, seaworthiness, and stability.
The hulls have a distinctive shape: sharp-ended with a flush deck, curved stem, deep lead keel, curved stern-
post, and moderate sheer.

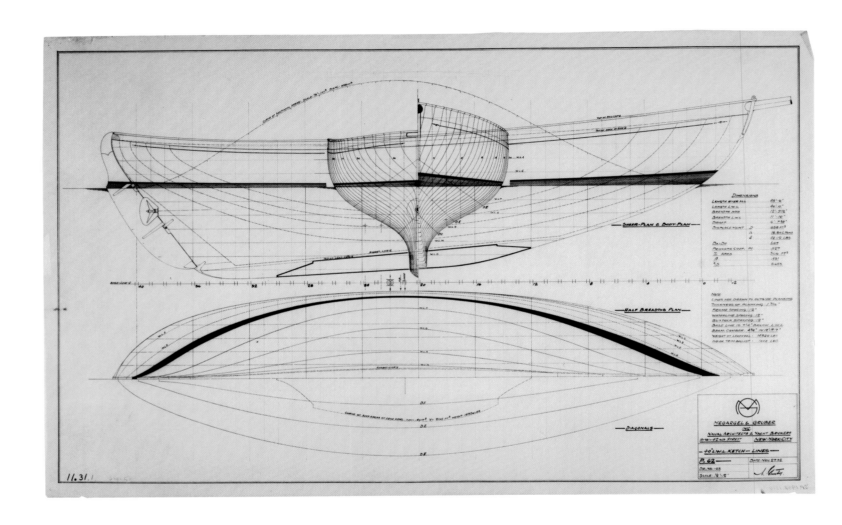

Henry Gruber, lines plan of an unidentified 45' 6" ketch yacht, 1932, ink on yellow tracing paper,
27 x 17 in. (11.31.1)

Gruber created this ketch to fulfill a request for the best possible offshore cruising yacht around 45 feet. The
design was required to be easily handled by two or three amateurs and to be safe and comfortable in the most
extreme bad weather. These demands are easily fulfilled by the Colin Archer–type rescue boat, also known
as the *redningsskoite*. Archer, a Norwegian designer and builder, launched his first rescue boat in 1893. A dra-
matic sea rescue in 1894 inspired the construction of 34 additional sailboats and, later, 17 powered boats.
Gruber's drafting on this lines plan shows an artistry and delicacy that are unsurpassed in Mystic Seaport's
plans collections.

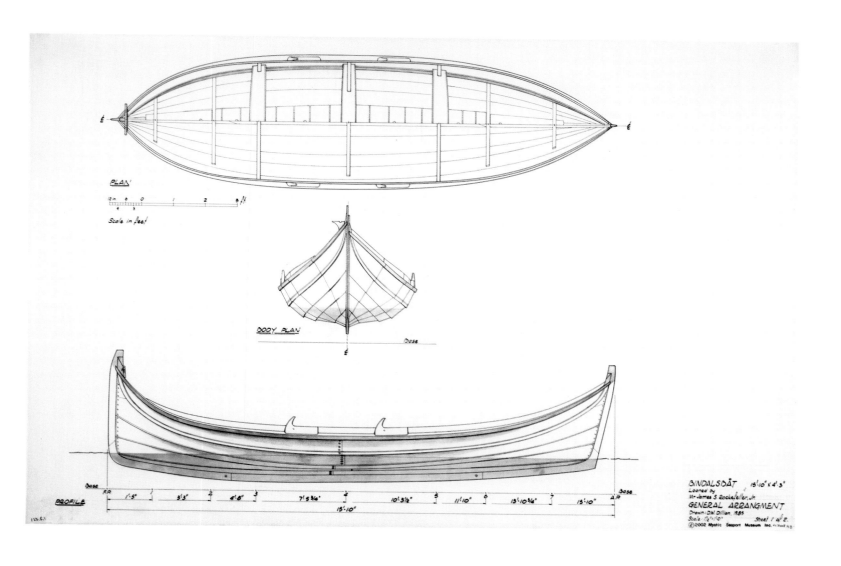

David W. Dillion, profile and construction plan of *Bindalsbåt*, 1985, ink and pencil on mylar, 36 x 24 in. (129.5.1)

Boatbuilder David Dillion is especially known for the precise measurement and documentation that make his plans of traditional watercraft both an indispensable record of past designs and a resource for future builders.

Owner James S. Rockefeller Jr. loaned this 16-foot boat to Dillion for measuring and documentation in 1985. The boat is Danish-built in the old Norse style. With its simplicity, clarity, and elegance, Dillion's beautiful plan far outshines the boat.

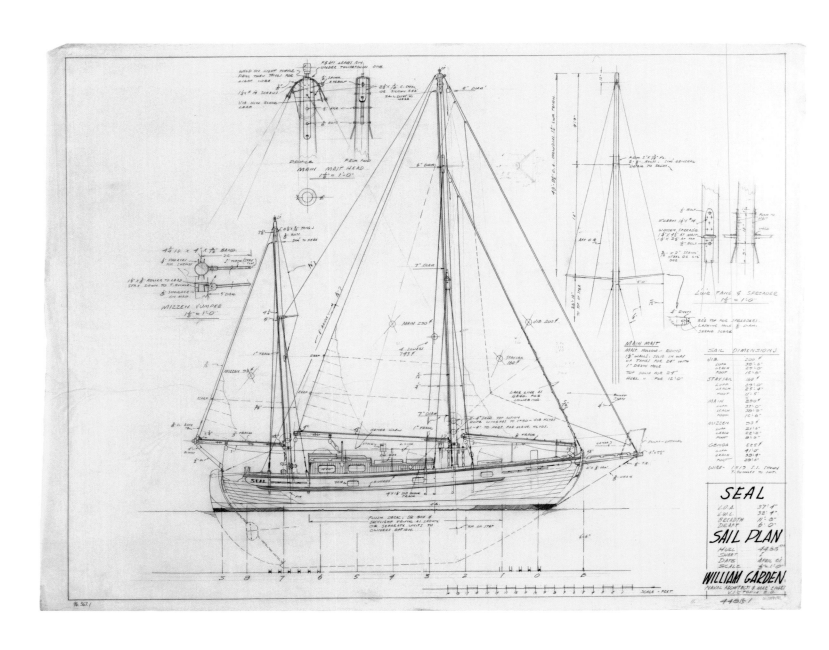

William Garden, sail plan of double-ended ketch *Seal*, 1953, pencil on tracing paper,
39 x 30 in. (96.367.1)

William Garden (b. 1918) studied boatbuilding at Seattle and went to work at boatyards in the 1930s. Becoming a licensed naval architect after World War II, he designed many popular yachts and commercial vessels. He relocated to British Columbia in 1968, and continues to design yachts.

Within the drawing:

AUXILIARY SLOOP
50' X 38 X 13' X 6'
FOR
DR. & MRS C.E.G. GOULD

PERSPECTIVE WITH EYE LEVEL 2' BELOW L.W.L. STANDING 57° OFF & 57'-5" AWAY

CLAMS EYE VIEW. CHARLIES' BOAT

96 200.12

William Garden, *CLAM'S-EYE VIEW. CHARLIE'S BOAT*, 1953, pencil on tracing paper,
17½ x 12 in. (96.200.12)

Garden designed this 50-foot sloop with cruising and racing in mind. The accommodations include many features to provide comfort in the cold Pacific Northwest climate, including a fireplace. This unique version of an isometric drawing is seen several times in the Garden collection, but very rarely elsewhere. It provides a customer-friendly view of the hull with a three-dimensional feel.

Henry J. Gielow, Inc., Music room details for steam yacht *Delphine*, 1921, ink on tracing cloth,
40½ x 28 in. (117.10.32)

A well regarded New York naval architect, Gielow received his first commission in 1903. Specializing in yachts, he designed both competitive sailing boats and large power yachts like *Delphine*.

Built by Great Lakes Engineering Works of River Rouge, Michigan, in 1921 for Horace and Anna Dodge, the 258-foot *Delphine* suffered a major fire on the Hudson River in September 1926 and sank. Mrs. Dodge, who had an enduring fondness for the yacht, had her raised and restored by James Shewan & Sons in Brooklyn. Under the name *Dauntless*, the vessel served the U.S. Navy as a patrol gunboat (PG-61) and flagship for Admiral Ernest King between 1942 and 1946. She was bought back by Anna Dodge, who owned her for another 21 years before selling her to the Lundeberg Seamanship School in Maryland. When the school sold her in 1986, she changed hands a few times and was eventually purchased by the Bruynooghe family in 1997. After a full restoration between 1998 and 2003, including the refurbishment of her original steam engines, the *Delphine* is now a charter passenger vessel. She is the largest active steam expansion yacht in existence.

Henry J. Gielow, Inc., joiner details in music room of steam yacht *Delphine*, 1921, ink on tracing cloth,
58 x 31 in. (117.10.22)

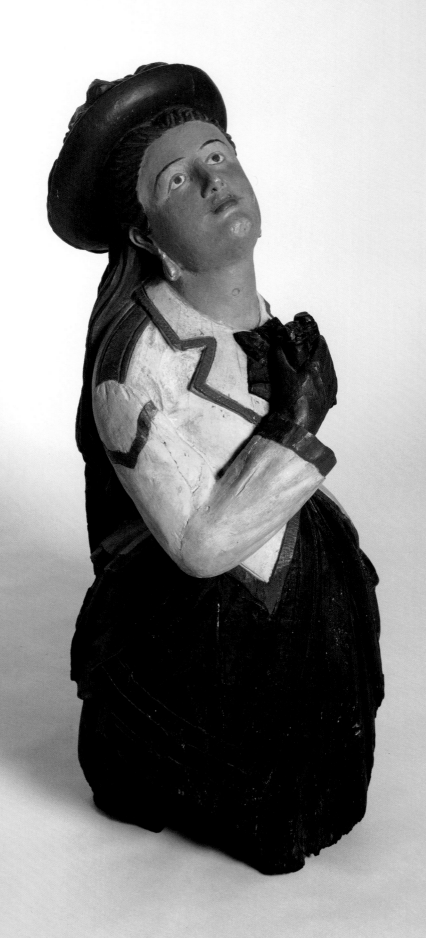

FIGUREHEADS

Above all other maritime artifacts, the ship's figurehead is the most recognizable and admired image that symbolizes the romance of the great age of sail. These wooden sculptures represented the name and spirit of the ship, transforming a lifeless object into a living thing.

From its beginning in 1933 with the acquisition of two examples, an East Indian figure called "Asia" and a female Victorian named "Woman with Binoculars," the figurehead collection at Mystic Seaport grew slowly. During these formative years the collecting was rather indiscriminate, and examples were acquired with little thought as to condition, provenance, or authenticity. Very little scholarly work had been published on the subject, and as a result the collection consisted of a blend of carvings of inconsistent quality and many with erroneous attributions. Over time, and through the efforts of the Museum's founders and supporters, the collection of figureheads has grown to over 60 examples.

Figureheads have been part of maritime history since ancient times. The first figureheads were fitted as talismans to ward off the evil in the unseen depths of the waters, not simply as decorations. The ancient Egyptians were among the first to use figureheads on their Nile boats. Images of gods and sacred beasts which adorned these ancient craft have been well documented on tomb wall paintings and funerary model boats. The following centuries saw the Greek and Roman empires similarly decorate their ships with images of their gods and heroes.

The serpentine shape of the great Viking ships naturally lent themselves to figureheads in the form of dragons and sea serpents designed to present a terrifying appearance to an enemy. These formidable mythological beasts continued to be favored even as ship design slowly changed from long double-ended craft to the bulky clinker-built vessels of the Middle Ages. During the Tudor period of the 1400s and 1500s, a dragon head could still be seen projecting out from the bow and striking fear into an adversary.

Ship ornamentation exploded during the 1600s and early 1700s, when almost every available surface was decorated with carved and gilded work. During this period, the lion became the predominant figurehead in most seafaring nations, a reign that would last over a hundred years. The latter half of the 1700s saw the shift toward ancient classical human figures; Roman and Greek gods and rulers stood proudly at the bows of naval and merchant vessels.

Prior to the Revolutionary War, American colonial figurehead design mirrored that of the mother country, with lions rampant. As the former colonies declared their independence, American figureheads also became more independent in design, reflecting the young nation's symbols of individuality, and this trend continued

Unidentified artist, woman with binoculars figurehead, ca. 1870, height 37 in. (1933.85)

Once believed to be from the Maine-built vessel *Lady Blessington*, this is now thought to be a British figurehead.

to increase into the 1800s. Images of Washington and Franklin stood alongside that of the American eagle and noble savage to represent the new nation's growing prestige upon the seas. Thereafter, the ship's namesake—be it businessman, wife, or popular figure—was increasingly represented in lifelike form at the vessel's bow.

The methods of producing figureheads were quite standard throughout western seafaring world. From the 1700s until sailing vessels and figureheads became obsolete in the early 1900s, the wood of choice was white pine. The typical figurehead was carved from one piece of wood with arms and other appendages often of separate pieces attached to the main body. An area of the back was left flat and a mortise cut in the bottom for fitting on the stem of the vessel. Figureheads were secured to their ships by long pins called drifts which were driven through the body and into the stem at the back. The finished figurehead was generally painted either white or in lifelike colors.

Today, Mystic Seaport's collection of figureheads consists of many notable examples, important both as historical objects and as sculptural works of art. A number of the pieces in the collection are identified to specific vessels, and therefore are of historic significance, since few figureheads have retained ties to their origins.

The enormous eagle from the famed clipper ship *Great Republic* is both a spectacular example of the ship carver's art and probably the most important figurehead in the collection (page 155). It measures just over five feet in length and is made up of seven pieces of white pine. This carved masterpiece by S.W. Gleason & Sons of Boston matches, in its grand dimensions, the ship for which it was created. The *Great Republic* was the brainchild of America's foremost shipbuilder, Donald McKay. Built at East Boston in 1853, she was the largest wooden merchant sailing ship ever constructed in the United States. After completion the 335-foot clipper was towed to New York to be loaded for her maiden voyage to Liverpool, but disaster struck. A fire broke out ashore, and burning cinders set the ship afire. The great ship was consumed to the waterline. Fortunately for posterity, the figurehead survived and was kept by Captain Nathaniel Brown Palmer who had the salvaged hull rebuilt. The figurehead remained in his family until it was purchased by the Museum in 1976.

In very rare instances, an unknown figurehead is identified through research. Such is the case of a female bust figurehead in the Museum's collection that remained unidentified for some 25 years. She turned out to be from the merchant schooner, later brig, *Eunice H. Adams*. The identification was made by a researcher, and a comparison with an early photograph of the vessel positively identified the carving. The identification also provided stylistic evidence that two other bust figureheads were also of New England origin. "Bust of a woman" (page 157) is very similar to the *Eunice H. Adams* in the treatment of the hair, dress, and collar. Both figures terminate with a shoulder drapery from the top of the back to the waist in front as well as with a decorative billet scroll with central rosette at the base. This type of figurehead was very popular for smaller merchant vessels and whalers.

The Mystic Seaport collection includes a number of outstanding British and European examples. The large bust called "Drake" is a particularly fine example of the ship carver's art depicting a man in Elizabethan dress, which is thought possibly to represent Sir Francis Drake (page 157). Its origins are unknown, but it is similar to busts that adorned some of the steel British warships of the late 1800s.

The "Orlando" is another fine example of a British naval figurehead. Believed to have come from the wooden steam frigate HMS *Orlando*, built in 1858, he is a bold, classic example of the British ship carver's art (page 154). The larger-than-life figure is depicted as a plume-helmeted warrior in armor. He is carved in a style referred to as a three-quarters figure, where the lower part of the body terminates with folded drapery around a billet scroll. He is also one of the best-preserved examples in the collection.

One of the Museum's earliest acquisitions demonstrates the uncertainties of figurehead identification. When the charming little female called "woman with binoculars" (page 150) was acquired from a Boston antiques dealer in 1933, she was named "Lady Blessington" and was believed to have come from a ship of that name built in Belfast, Maine. However, she is clearly of English origin and relates to others of similar design. These small Victorian female figureheads were very popular in Great Britain during the latter half of the 1800s. They were carved depicting women in the latest fashionable Victorian dress of the period and were probably not portraits of specific individuals but, rather, a generic type.

One of the most popular and unusual carvings in the collection is a rare double figurehead called "sisters" (page 156). The carving depicts two little girls posed as if about to dance together. Both are clothed in elaborate multi-layered dresses with pantalets trimmed in lace. Their hair, worn loose in long curls, is crowned with wreathes of roses. It was common to name vessels after siblings such as "Mary & Susan" or "Two Sisters"; however, double figureheads depicting siblings or couples were rare. Only two others are known to exist. While originally believed to have come from the Salem-Newburyport area of Massachusetts, "sisters" is more likely European, possibly executed by Danish ship carver Henrik Julius Moen, who is known to have carved a similar double figurehead.

During the life of their ships, figureheads were typically kept in good condition, although vulnerable areas such as extended arms, legs, and noses were often lost due to storms or accidents. But they were repaired when necessary and were frequently repainted. It was after they were removed from the vessels that figureheads suffered most. They were set up outdoors in gardens or mounted on the sides of buildings. Very few had the luxury of being placed indoors. As a result, many decayed and were ultimately lost, and those that survived were riddled with rot and other forms of deterioration. Almost all surviving figureheads have been restored to some degree. Even with its examples of restoration and reinterpretation, the Mystic Seaport collection of figureheads stands out as one of the nation's finest. Long after the ships they graced have been destroyed, these wooden images stand as silent pilots, still speaking to the essence of the time when men went down to the sea in wooden sailing ships, guided by the spirit that was the ship's figurehead.

RYAN M. COOPER

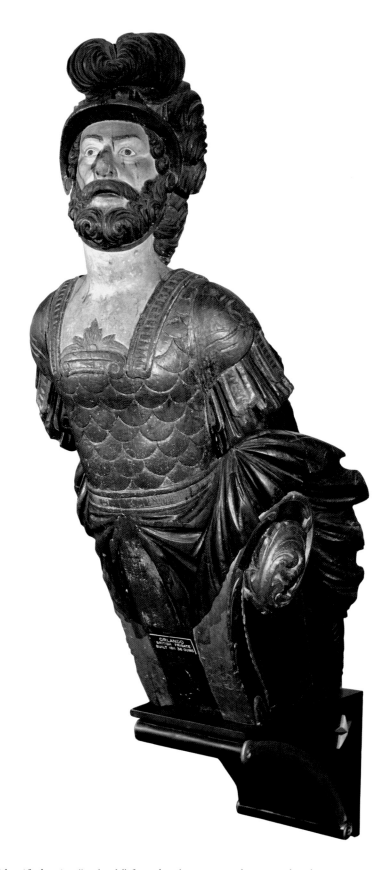

Unidentified artist, *"Orlando"* figurehead, ca. 1858, white pine, height 68 in. (1934.83)

This is believed to be the figurehead of the British frigate HMS *Orlando*, launched in 1858.

S.W. Gleason & Sons, *Great Republic* figurehead, 1853, white pine, length 61 in. (1948.942)

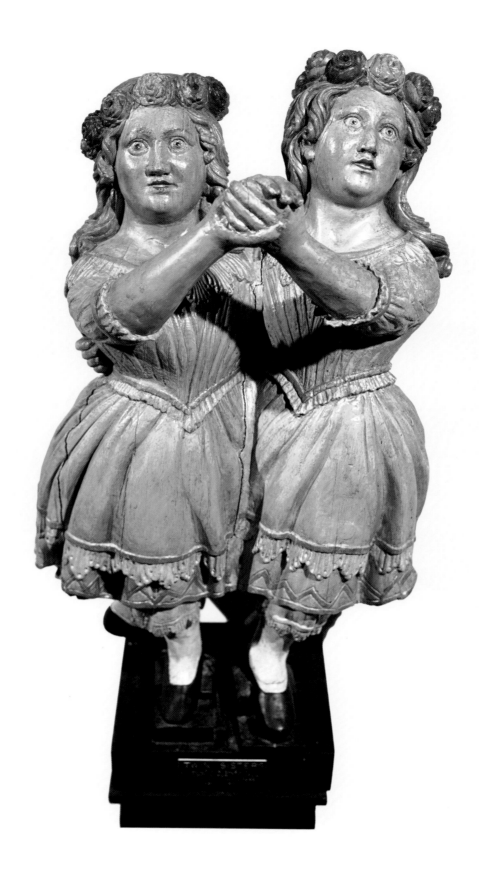

Unidentified artist, "sisters" figurehead, ca. 1850, height without base 37 in. (1957.358)

Unidentified artist, bust of a woman figurehead, ca. 1850, height 16 in. (1953.87)

Unidentified artist, "Drake" figurehead, Scots pine, height 55 in. (1945.642)

ACKNOWLEDGMENTS

The idea for *America and the Sea: Treasures from the Collections of Mystic Seaport* originated with William Cogar, the former Vice President for Collections and Research at Mystic Seaport. The book represents the collaborative efforts of almost the entire staff of the Museum. Mary Anne Stets, Curator of Photography and Director of Intellectual Property, served as project coordinator, and her efficiency and energy were essential to its completion in a timely manner. Information on the collections and individual objects was provided by the curatorial staff: William N. Peterson, Senior Curator; Philip L. Budlong, Associate Curator; Fred Calabretta, Associate Curator of Collections; Georgia W. York, Registrar; Paul O'Pecko, Director G. W. Blunt White Library; and Maria Bernier, Ships Plans Librarian.

Andrew W. German, Director of Publications, edited the text and wrote the captions.

Photography Research Associate Amy German worked tirelessly to secure the images needed for reproduction. Claire White Peterson, Manager of Photography Services, and Museum Photographer Judy Beisler photographed the objects that are being reproduced here for the first time; and Chris White, Assistant Supervisor of Conservation, and Chris Cardoni, Collections Assistant, assembled and handled the works to be photographed.

Special thanks are due to Katy Homans for the book's elegant design and typography, and to Robert Hennessey who made the duotone and color separations.

Finally, Patricia Fidler, Art and Architecture Publisher, and Carmel Lyons, Art Book Publishing Coordinator, at Yale University Press were supportive and helpful throughout.

C. S.

PHOTOGRAPHY CREDITS

Judy Beisler: title page, 10, 15, 16, 17 (all), 20, 22, 23, 26, 27, 30, 31, 32, 33, 34, 35, 36, 40, 42, 43 (bottom), 44, 45, 47, 94, 96 (top), 97 (both), 98, 106, 107, 108, 109, 112, 116, 117 (all), 125, 127, 136, 137, 139, 141, 142, 143, 144, 145, 146, 147, 148, 149

Judy Beisler and Claire White-Peterson: 18

Jeff Dykes, 9, 11, 95, 96 (bottom), 99, 100, 104, 105, 110 (both), 111 (all), 120, 122 (both)

Lester Olin: 154, 156

Mary Anne Stets: 6, 12, 21, 24 (both), 25, 28, 29, 37, 38, 39, 41, 46, 48, 49, 93, 118, 119, 123, 126, 157 (bottom)

Mary Anne Stets and Claire White-Peterson: 124, 150, 155, 157 (top)

Claire White-Peterson: 19, 43 (top)